IMAGES
*of America*

# CULVER CITY

(Continued from Page Four)

## HOW THE CULVER CITY SALES FORCE GETS THE BUSINESS

The work of the past year has been extremely interesting from a sales manager's standpoint. There has been so much absolute contentment and satisfaction with the purchasers and so very little discontent. I do not believe that there is a single purchaser today in Culver City who has a legitimate, reasonable complaint to make, as the company has kept all its promises regarding improvements and buildings to be erected in Culver City.

The policy of the sales department has been such that not only does the company have a high-class, clean-cut, intelligent, well-informed set of men and women selling Culver City property, but in addition to this, the company caters to set the property to people of intelligence, discernment and ability to build substantial homes or business buildings. The terms, too, are such that the illiterate and undesirable classes are conspicuously absent.

The sales department entertained during the last year in Culver City more than fifty thousand (50,000) guests; all these guests were entertained in the Culver way, which is a little better than the best.

The results in figures, dollars and cents, are more than gratifying, but personally I would like to go on record as expressing my feelings toward another kind of results, results in satisfaction to the company, and to myself, that we have born a part in this tremendous selling success. This has been a great year in spite of unfavorable conditions, and we do not take much of the credit to ourselves, the property just simply sells itself.

The coming year should see the town grow beyond our wildest hopes, as we are approaching a year in the annals of real estate history, when thousands upon thousands of easterners and middle westerners will come to us and live among us.

Speaking for the sales department of the Harry H. Culver company, I am tremendously well pleased with the results of the past year.

## CULVER CITY NOTES

The Western Loan & Building Company of Salt Lake City has established a branch office in Culver City, with H. G. West as local manager. The company will specialize in the making of loans for residential and business building purposes in Culver City, and a large amount of the stock has been subscribed by residents of this community.

The Ladies' Aid of Culver City M. E. Church will hold a social Thursday evening, Nov. 5, at the home of Dr. and Mrs. Ash, on Warner avenue. A delightful program will be rendered, and a good time is promised to all. Everybody cordially invited.

The Pacific Electric Railway company has transformed the property adjoining their power station into a park which will become a part of the Culver City park system. A large shipment of tropical shrubs and rare plants have arrived and will be set out immediately.

G. A. Hechler, a well-known Los Angeles contractor, laid the foundation for two six-room residences on Main street this week. Both houses are being built on rush orders and the contract calls for completion in six weeks. These houses were sold by Contractor Hechler before the ground was broken.

The Ladies' Aid of the Culver City M. E. Church held their first meeting Thursday afternoon at the home of Mrs. Cecil Leisinger, with a good attendance. Meetings will be held every two weeks. All the ladies of Culver City are invited to attend. The next meeting will be held at the home of Mrs. J. J. Higman, Ivywild.

Chas. H. Rothwell and Mrs. Rothwell have moved to their new home on Valley street, corner Villa. Mr. N. P. Larsen will make his home with them. Mr. Rothwell takes charge of the Culver City office of the Rothwell Realty company, in the Culver block.

The Ivywild Improvement Association met in social session at the home of Mr. and Mrs. Trippensee on Hossin avenue last Saturday evening. The beautiful home presented an attractive appearance, decorated as it was in a manner befitting the Halloween season. Ghosts and witches could be seen in different parts of the house. A fortune telling den was to be found on the front porch. The guests, numbering 80, were entertained with Halloween games and it is needless to say that everyone present

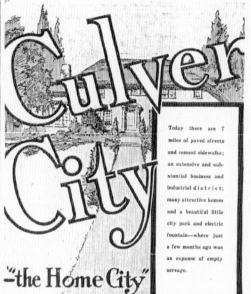

Today there are 7 miles of paved streets and cement sidewalks; an extensive and substantial business and industrial district; many attractive homes and a beautiful little city park and electric fountain—where just a few months ago was an expanse of empty acreage.

Where all Home-Building records are being smashed. As sure as the electric magnet draws particles of steel—Culver City is attracting home-builders and home lovers from all sections of Southern California.

A great railway manager said recently, "Culver City has a WONDERFUL LOCATION—that asset alone will make it a leading city."

The growth of Culver City in 10 months is the most remarkable suburban estate development of 1914.

Culver City will surprise you, captivate you, convince you. You've seen what has happened at Hollywood, Pasadena, Long Beach and Venice. Culver City's "next!" See this new wondertown and your good judgment will do the rest.

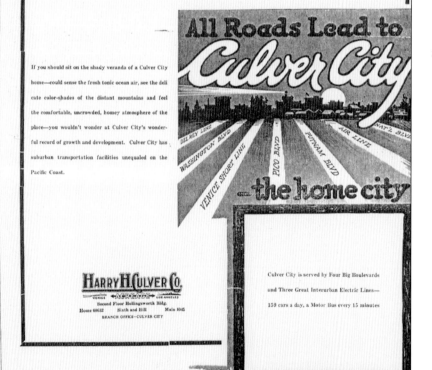

If you should sit on the shady veranda of a Culver City home—could sense the fresh tonic ocean air, see the delicate color-shades of the distant mountains and feel the comfortable, uncrowded, homey atmosphere of the place—you wouldn't wonder at Culver City's wonderful record of growth and development. Culver City has suburban transportation facilities unequaled on the Pacific Coast.

Culver City is served by Four Big Boulevards and Three Great Interurban Electric Lines— 159 cars a day, a Motor Bus every 15 minutes

Shown here is the *Culver City Call* newspaper, dated December 29, 1913. (Courtesy Cerra Collection.)

# IMAGES
# *of America*

# CULVER CITY

Julie Lugo Cerra

ARCADIA

Published by Arcadia Publishing
Charleston SC, Chicago IL, Portsmouth NH, San Francisco CA

Printed in the United States of America

Library of Congress Catalog Card Number: 2004104887

For all general information contact Arcadia Publishing at:
Telephone 843-853-2070
Fax 843-853-0044
E-mail sales@arcadiapublishing.com
For customer service and orders:
Toll-Free 1-888-313-2665

Visit us on the Internet at www.arcadiapublishing.com

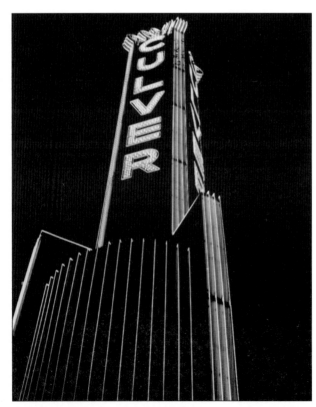

The Culver Theatre tower has welcomed all to Culver City since 1947. (Courtesy Culver City Historical Society Collection.)

# CONTENTS

# ACKNOWLEDGMENTS

As with any book, it takes a lot of behind-the-scenes work to bring the finished product to fruition. Culver City offers a broad scope of people and historic changes that makes the community an interesting study. Although I have personally acquired an enviable collection of photos as a sixth-generation Californian and as the city historian in my home town, my partner is the Culver City Historical Society. My special thanks go to the board, led by President Steven Rose. In the area of movies, my best historic guide remains Culver City's longtime friend and supporter, Roger Mayer. My thanks to Sony Pictures Entertainment for guidance and support, Carolyn Cole of the LAPL who is a wonderful resource and, of course, to the City of Culver City.

The story of a community is clearly enhanced by family photos. Special thanks to Robert Battle, great-grandson of city founder Harry Culver, for sharing photos from the Culver family album. Pat Culver Battle, Harry Culver's daughter, always offered insight into her family with love. We miss her so. Pat would be so proud that Robert has become the family historian. Locals Marilyn Clark, the Eskridges, Ron Coombs, Jozelle Smith, Ed Johnson, Stuart Freeman, Paul Pitti, June Caldwell, George Petrelli, Jean Barker, Fred Machado, Martha Sigall, Robert Elliott, Steve Newton, and Cathy Zermeno. . . Every time I thought I had enough, one of them came up with another great photo!

Last on this list, but my highest priority on a daily basis, is my family, who continually offer their support. Thank you, Sam, Michele, and Kevin.

# INTRODUCTION

Culver City is the realized dream of Nebraska-born Harry Hazel Culver. When Culver arrived in California in 1910, he began his real estate training with I.N. Van Nuys. By 1913, his study of the landscape led him to the perfect location for his balanced community.

These were rich lands traversed in earlier times by the Gabrielinos, Native Americans who respectfully worked the open space and waterways to gather their food. They made their board boats from local trees and waterproofed them at nearby La Brea Tar Pits. The Gabrielinos were peace-loving people with a well-developed vocabulary, known for their expertise in basket-making.

The rancheros first developed the area that was destined to become Culver City. It was long after the Spanish discovery of California that Agustín Machado rode his fastest steed from dawn until dusk to establish Rancho La Ballona. On his legendary ride, starting at the foot of Playa del Rey's hills, Machado garnered the 14,000-acre rancho for his brother Ygnacio Machado, Felipe and Tomas Talamantes, and himself. To the east, the Higueras claimed Rancho Rincón de los Bueyes. It was primarily from these two ranchos that Culver City was carved.

What did Harry Culver see in this land? He saw open fields, ripe for development, halfway between the pueblo of Los Angeles and Abbot Kinney's "Venice of America." He saw a main transportation route. In fact, his early ads read "All Roads Lead to Culver City." And he saw Thomas Ince, noted for his westerns, filming a movie with canoes on La Ballona Creek.

Harry Culver's vision took the form of a community for families with an economic base to support them. He was an entrepreneur extraordinaire whose dream city evolved as he planned, so that eventually the city seal bore the name, "The Heart of Screenland."

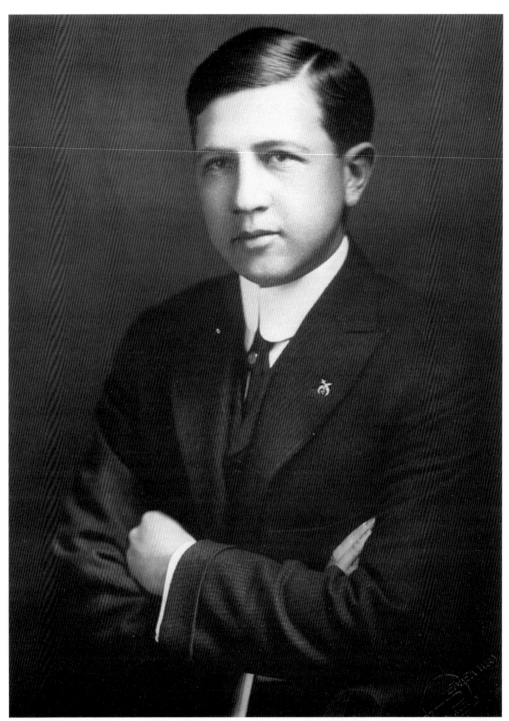

Harry Culver was born in Milford, Nebraska, on January 22, 1880. This 1913 portrait was taken the year he announced his plans for Culver City at the California Club in Los Angeles. He not only learned the ropes in real estate from I.N. Van Nuys, but he also worked with Fritz Burns, who developed Playa del Rey. Culver donated land to establish Loyola University (LMU today), knowing universities drew residents to nearby towns. (Courtesy Culver Collection.)

# One

# HARRY CULVER
# AND HIS DREAM

The Culvers were descended from Edward Colver, who arrived in Massachusetts from England in 1635. Harry Hazel Culver was born in Milford, Nebraska, on January 22, 1880, the middle child of five. He and his three brothers and sister grew up on the family farm. The military life was held in high esteem by the Culvers, and although underage, Harry enlisted in the Spanish American War, where he served as a trumpeter.

After attending Doane College, Culver spent three years at the University of Nebraska. He financed his education through a variety of jobs, including taking in laundry. Ahead of his time, Culver started a bottled water business with his father. Harry Culver's daughter Patricia, referred to her grandfather Jacob Culver as "a strong disciplinarian who taught his children the work ethic." Father and son learned the hard way on that particular venture to keep the controlling interest in any future business.

In 1901 Culver left for the Philippines to work in the mercantile business and then as a reporter for the *Manila Times*. He also worked as a special agent in the Customs Office.

Culver arrived in California in 1910. After learning real estate from seasoned veteran I.N. Van Nuys, Culver found a perfect spot for the city destined to carry his name. On July 25, 1913, Culver announced his plans at the California Club in downtown Los Angeles. In his speech he made reference to the "fertile acres" and "fortunates who call California home." He also spoke of drawing a line between Los Angeles and the oceanfront in Venice, only to find the halfway mark as intersecting electric (railway) lines, or "the logical center for what we propose to develop, a town site." And so he did!

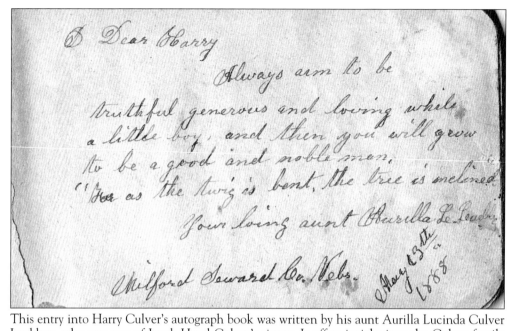

This entry into Harry Culver's autograph book was written by his aunt Aurilla Lucinda Culver Luebben, who was one of Jacob Hazel Culver's sisters. It offers insight into the Culver family philosophy. She related to her eight-year-old nephew, "Dear Harry, Always aim to be truthful, generous and loving while a little boy and then you will grow to be a good and noble man. . . As the twig is bent, the tree is inclined." (Courtesy Culver Collection.)

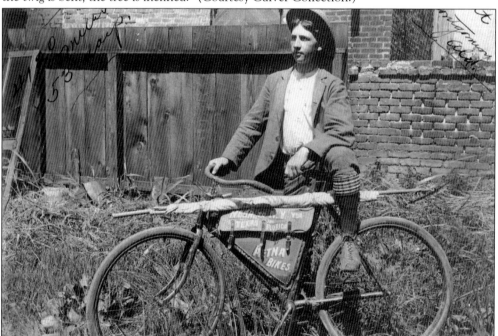

Harry Culver on his bicycle in Montgomery, Alabama, probably taken during a 53-day endurance ride. Inscribed on the back of a photo of the bicycle: "Colton bicycle 'Aetna' used by Harry H. Culver in winning world's endurance race—Harry rode later in exhibition (3 days) in Madison Square Garden, N.Y.C. app. 17 yrs. old." (Courtesy Culver Collection.)

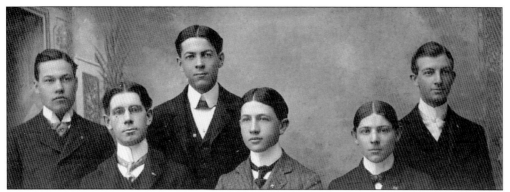

Shown is Harry Culver, fourth from left, at the University of Nebraska in 1898, after he had spent a year at Doane College. Culver worked his way through college doing a variety of jobs, which included taking in laundry. He was a young entrepreneur. (Courtesy Culver Collection.)

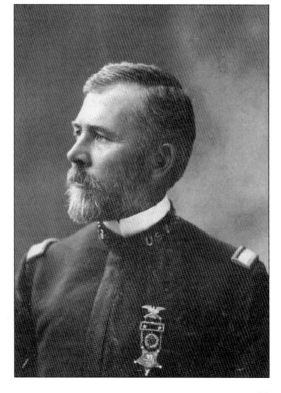

Culver's father, Jacob, was a drummer boy at age 16 in 1861. An older Jacob Hazel Culver is pictured in uniform. According to his granddaughter Patricia, he served in three wars without a scratch. Jacob Culver married Ada Davison and they had five children, four boys and one girl. Harry Culver founded the Pacific Military Academy in honor of his father. (Courtesy Culver Collection.)

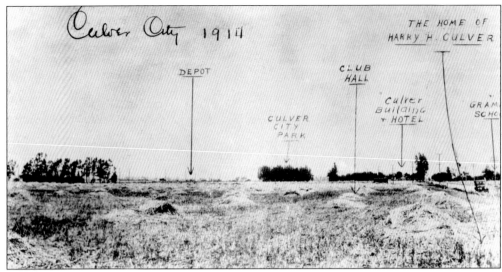

Look at Culver City in 1914, a year after Harry Culver declared his intent to develop a city! The "depot" refers to what became Culver and Venice Boulevards, with Culver City Park, later Media Park, next to it. The Club Hall was farther west, while Culver Grammar School was built south of the Hunt (Culver) Hotel. (Courtesy Culver City Historical Society Collection.)

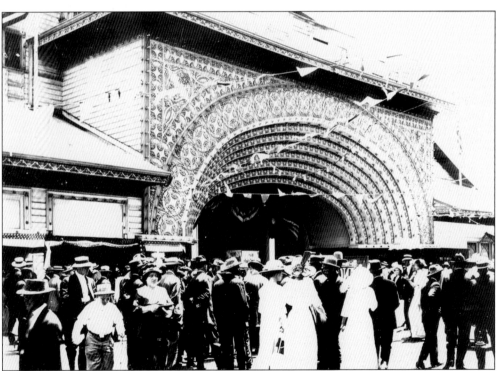

Harry Culver planned his city halfway between the Story Building in Los Angeles and Abbot Kinney's "Venice of America." The Venice Pier is shown about 1910. Crowds enjoyed the entertainment at the ballroom, where performances were given by Sarah Bernhardt and other noted professionals. (Courtesy Culver City Historical Society Collection.)

Lillian Roberts attended Cumnock Elocution-Dance School and by the age of 16, she was acting. Culver first saw her when she was 19, waiting to take the Venice Short Line downtown to go shopping. She was already being groomed by Thomas Ince to be an actress. Culver was so much older that he had to throw a party for "the newcomers" in town to meet her. They married in 1916. (Courtesy Culver Collection.)

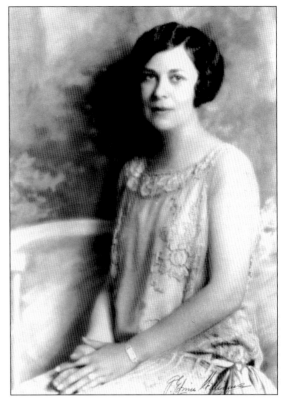

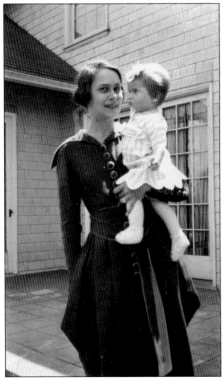

Here are Lillian Roberts Culver and daughter Patricia at 11 months, in 1918. Patricia was born the month before Culver City was incorporated, in 1917. Harry Culver first provided a home for the little family on Delmas Terrace in Culver City. It was moved in the mid-1920s to Club Drive, where it still stands. From there, Culver could manage the progress on the family's new Wallace Neff mansion, which was being built on Shelby Drive. (Courtesy Culver Collection.)

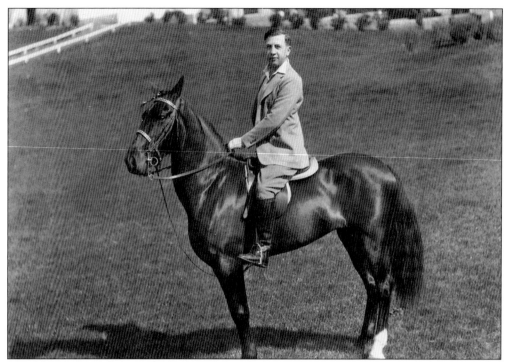

Harry Culver was quite a horseman. This recognizable photo was taken on the lawn of Pacific Military Academy, located north of Venice Boulevard, on a hill behind Hamilton High School. Culver taught his daughter to ride English style on the grounds of this school. During World War II, servicemen stationed at "Fort Roach" in Culver City lived in the dormitories. (Courtesy Culver Collection.)

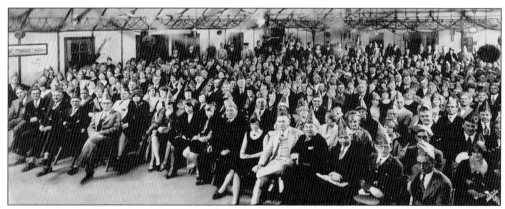

Harry Culver's sales force of hundreds is shown celebrating in 1928. Culver had his office on the second floor of his "skyscraper" six-story hotel. Culver's promotions were in keeping with his philosophy: "What seems to attract people is something moving." As Art Hewitt said in a 1955 article in the *Los Angeles Herald*, "Culver City was moving. Some people said it was jumping." (Courtesy Culver Collection.)

14

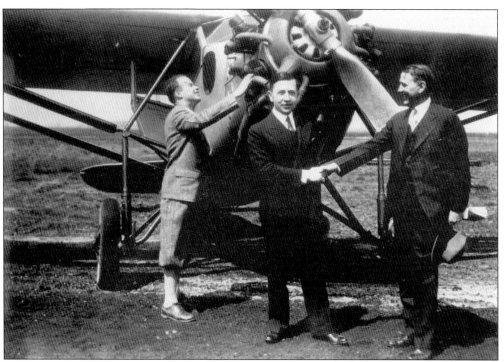

Harry Culver headed the California Real Estate Board, and later, the national organization. He flew with his pilot, and often his wife Lillian and daughter Patricia from the Culver City Municipal Airport. The back of this family photo reads, "1929, Capt. Jas. Dickson (pilot) - Harry Culver - Herbert Nelson - 6-passenger Stinson Detroiter." (Courtesy Culver Collection.)

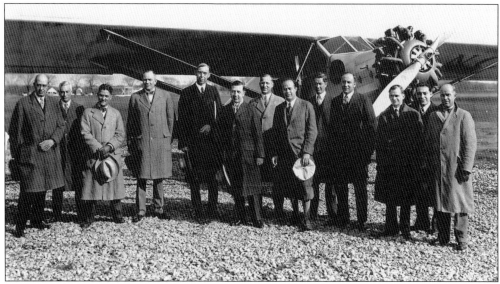

In 1929 Culver made it his business to fly across the country and speak in 640 cities over a year's time. Here he is in Madison, Wisconsin, November 1, 1929. (Courtesy Culver Collection.)

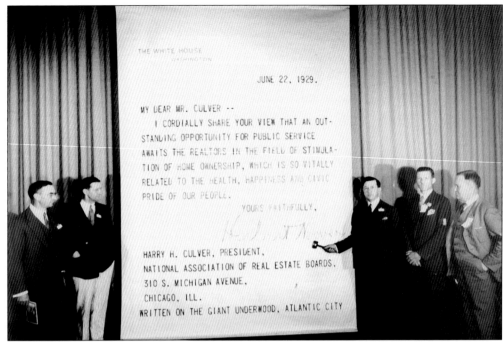

Home ownership was the subject of President Hoover's letter to Harry Culver. In a clipping from a 1928 Washington, D.C., *Sunday Star*, a story told of young Patricia Culver's response to her trip: "It was fine. I read 50 pages in my storybook." The article's author went on to say, "When tiny girls are so accustomed to flying that they read their storybooks while doing it, we are perhaps making some progress, in a few instances, toward the air age."

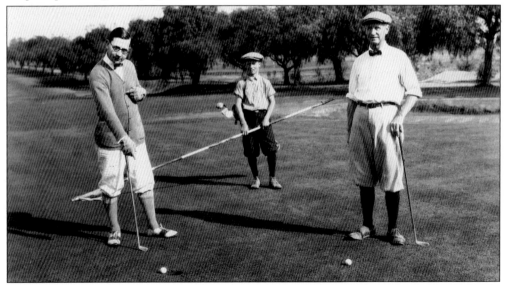

Harry Culver wanted his city to be a balanced community. He sold homes, supported schools, provided for an economic base, and believed in recreation. He helped found the California Country Club. This family photo identifies "Harry H. Culver, Judge George Somerville (co-founder of California Country Club), and caddy." His daughter described Culver as a "fabulous rider, swimmer, ice hockey and tennis player." He even owned an "H. Culver Ice Hockey Team."

## Two

# DOWNTOWN
# CITY TOUR

Harry Culver filed "Main Street" with Los Angeles County in 1913. It became home to banks, hardware stores, department stores, shoe stores, and pharmacies. You could visit the bakery, the grocery store, and spend time at a card shop or a music store. It became recognizable for its movie location shots and according to some as "the shortest Main Street in the world."

Commercial ventures radiated from the Main Street hub. Harry Culver continued to purchase property to develop along with Camillo Cereghino of the Washington Boulevard Improvement Company. A creative businessman, Culver found ways to market his plan. Busloads of interested people took advantage of his offers of a "free lunch." He gave one of the new residential lots to the winning family of the "prettiest baby contest." He held races. He used klieg lights to draw attention to the city that would use them later for movie premieres.

By 1924 Culver replaced the first theater and its second-floor city offices with a six-story skyscraper hotel. At one time, because of the traffic at the Culver-Washington "X," a tunnel served as a passageway under Washington Boulevard from Culver's landmark hotel to the corner of Van Buren Place. A new theater opened on Culver Boulevard, and the city offices expanded into a city hall, police department, and fire department on nearby Van Buren Place. Other little hotels like the Adams Hotel and the Washington Hotel became realities. Restaurants and other businesses thrived. Thomas Ince established his second major studio in Culver City's downtown area in 1919. By the late 1920s bonds financed a new fire station and city hall, which housed the police department.

Today, downtown is undergoing successful redevelopment. The once pedestrian-friendly streets are proving that history can repeat itself, only better.

# Downtown Culver City Walking Tour

Begin at Main Street and Culver (plaque NE corner)
Walk North, note the old Steller Hardware Store on the left
Right onto Venice, note The Ivy Substation ahead
Right onto Canfield
Right onto Culver to The Citizen Building
Walk back to Ince, cross Culver, then Washington
Walk right, in front of The Culver Studios
Stop by the Culver Hotel
Walk to Irving, noting mural around corner
Cross Irving, walking past the Fire Station
Walk past Meralta Plaza
Look left down LaFayette to the Spanish Bungalows
Note Washington Building across the street
Stop at City Hall, and walk around courtyard
Note Post Office at Lincoln
Left onto Duquesne, noting the marker
Walk Past CCPD
Note Gale Home at 4161 Duquesne
Walk to Lucerne, where Egyptian House was to the left
Cross Duquesne noting Transportation Facility, Bill Botts Field
Walk North (right) back up Duquesne, noting Coombs house at 4245
Make a left onto Farragut
Cross Lincoln noting the Pitti House
Turn right at Madison, noting Cereghino home at SE corner
Walk up to Culver, noting Tudor home
Cross Culver, noting Sony Pictures Plaza on right, studio entry on left
Left on Washington to Jasmine
Cross Washington at Jasmine noting colonnade
Pass beyond St. Augustine's walking east
Note Culver Theatre on right at Duquesne, Legion Building up Hughes
Walk Past Freeman Plaza, the site of Freeman Market
Cross Watseka to the Hull Building, noting marker
Continue back to Main Street, noting old B of A building on corner.

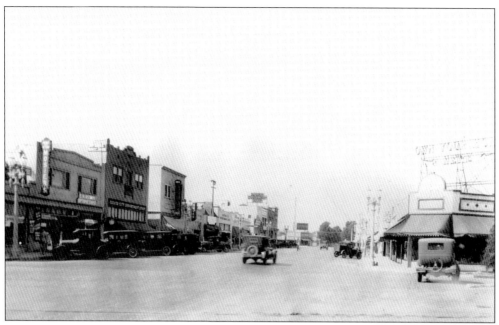

In 1928, Main Street, Culver City was thriving. Businesses crowded both sides of the street, and city founder Harry Culver was enticing new residents daily. His sign offered the opportunity for home ownership, and his ads drew families to Culver City, the "home place." The Steller and Skoog Hardware Store has been on this street since 1923. Venice Boulevard is at the end of the block. (Courtesy Culver City Historical Society Collection.)

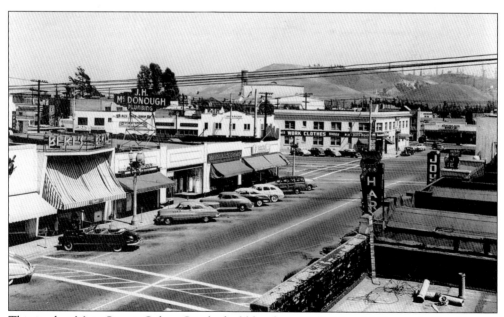

This is what Main Street, Culver City looked like about 1950. Note McDonough Plumbing on the east side of the street. Looking south, the Adams Hotel is across Culver Boulevard, on the corner behind the store selling work clothes. The Baldwin Hills are in the distance. (Courtesy Cerra Collection.)

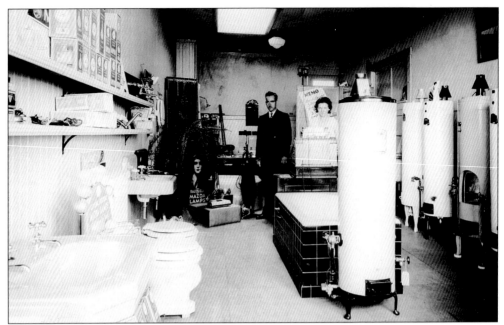

According to local records, J.H. McDonough Plumbing was established in 1914. It was located at 9423 Culver Boulevard and on Main Street. This 1931 interior shot of the plumbing shop offers a step back in time, when Harvey R. Hall, pictured, was the salesman and copy writer. (Courtesy Culver City Historical Society Collection.)

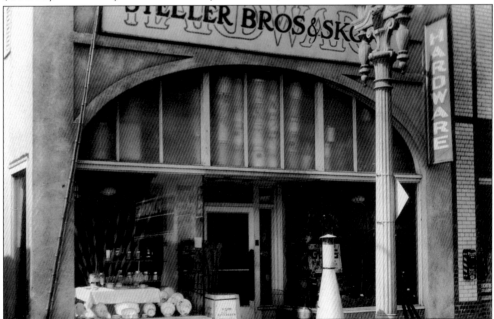

When walking up Main Street toward Venice Boulevard, few detect the change in the street name. Steller Bros. & Skoog Hardware was first located just across the alley on the west side of the street. The name change pays tribute to the city's irregular boundaries from the beginning. From the alley north, the street changes from Main Street to Bagley, which is actually in the City of Los Angeles. (Courtesy Culver City Historical Society Collection.)

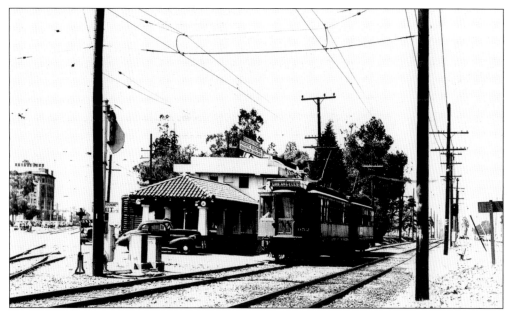

Turning right onto Venice Boulevard from Main Street (Bagley) and across Canfield Street, one can find the first local park, named Media Park. An inbound Venice Short Line car can be seen on the tracks along the Culver City–Palms Depot at the edge of this late 1930s photograph. In the distance, down Culver Boulevard, Culver's six-story "skyscraper" hotel sits at the foot of Main Street. (Courtesy Culver City Historical Society Collection.)

Although the Ivy Substation and Media Park were in Los Angeles, they became an unwelcome entry into Culver City. Railroad preservationist David Cameron heard that development was in the works on Venice, so he quickly completed the process of putting the Ivy Substation on the National Register of Historic Places to save the structure. Culver City then signed a long-term lease (50 years) for the property and turned it into a cultural resource, with the help of Culver City Redevelopment Agency funds. (Courtesy Cerra Collection.)

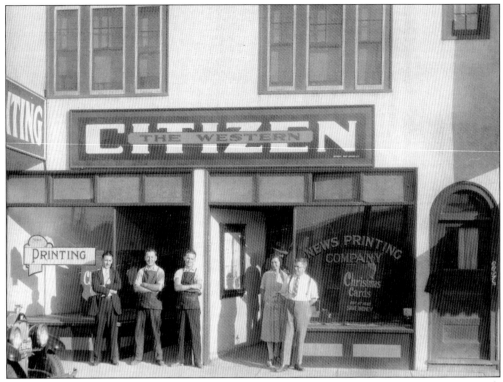

Eugene and Catherine Donovan moved to Culver City in 1923 from San Francisco with memories of earthquake and fire, wanting to house their business in a "first class" safe structure. Their dream was to create the most up-to-date printing and publishing establishment in this area. They established their "Western Citizen" under the management of their son Roy, temporarily across from the land on which they would build their dream. (Courtesy Culver City Historical Society Collection.)

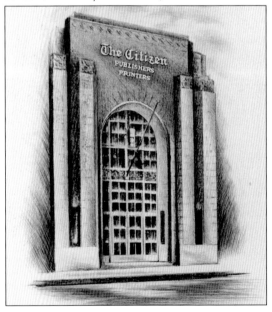

Orville L. Clark's design for the Landmark Citizen Building became a reality as its doors opened on December 6, 1929 at 9355 Culver Boulevard. *The Citizen Newspaper* was "dedicated in perpetuity to the service of the people that no good cause shall lack a champion and that evil shall not thrive unopposed." Three generations of the Donovans ran the family business, and the structure is on the National Register of Historic Places. (Courtesy Culver City Historical Society Collection.)

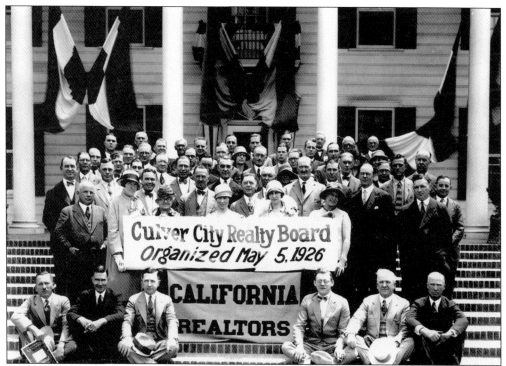

City founder Harry H. Culver was well known throughout the county for his real estate expertise. He is pictured sitting on the steps of the DeMille Studios with his fellow Culver City Realty Board members, to the left of the California Realtors sign, hat in lap. (Courtesy Caldwell Collection.)

Ince's second studio is in the background of this "pedestrian friendly" image of Main Street in the 1920s. Behind the flagpole is the Adams Hotel, which housed the "overflow" of "munchkin actors" in Culver City to film *The Wizard of Oz* in the late 1930s. (Courtesy Cerra Collection.)

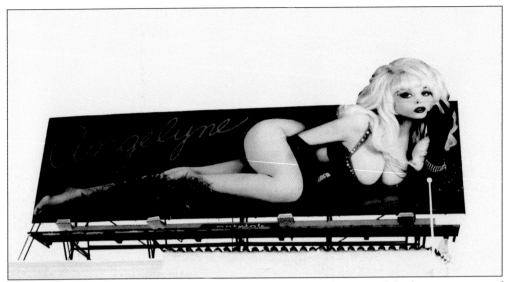

In days gone by, billboards in Culver City were a common sight. One of the last was on top of the Plato Building at the western edge of The Culver Studios. Angelyne, who paid for her own billboards, looked over to the Culver Hotel, in this case. (Courtesy Cerra Collection.)

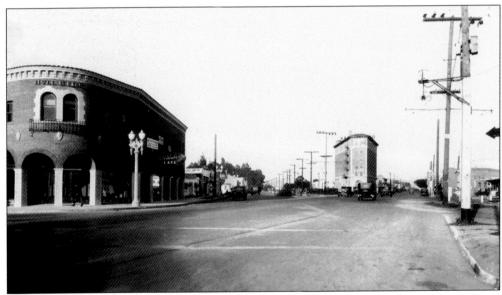

When *The Wizard of Oz* was being filmed, the "munchkins" were housed in Culver's Hotel Hunt in the distance, shown c.1927. Famous owners included Red Skelton and John Wayne. Dwight D. Eisenhower had campaign offices in the hotel when he was running for president, and he visited Culver City as did his running mate, Richard Nixon. (Courtesy Culver City Historical Society Collection.)

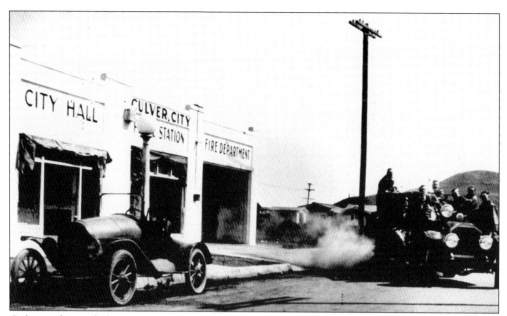

Culver relocated the city offices around the corner on Van Buren, and the new "complex" included a city hall, fire station, and police station. These served as temporary quarters until the new city hall was financed and opened down the street on Culver Boulevard in 1928. This active street scene took place c. 1923. (Courtesy Culver City Historical Society Collection.)

For a time, Culver City was "The Heart of Screenland" with no theaters. In 2000, the City Council was happy to break ground for the new complex, which sits at the edge of the new town park. Pictured, from left to right, are Mayor Ed Wolkowitz and council members David Hauptman, Steven Rose, Carol Gross, and Alan Corlin. The Culver Hotel, behind, holds local landmark status and is listed on the National Register of Historic Places. (Courtesy Freeman Collection.)

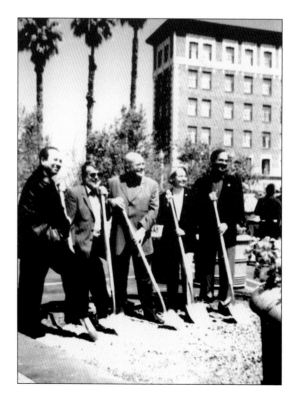

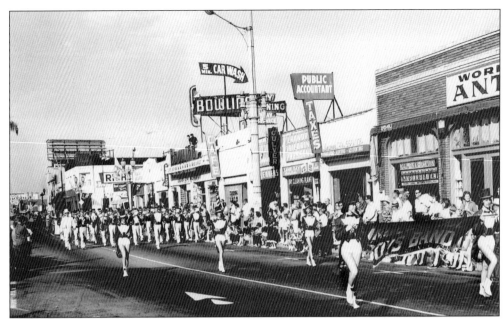

In the 1950s, residents lined Washington Boulevard across from the Culver Hotel to watch the annual Fiesta Parade. Irv's Richfield Station was on the corner of Van Buren, with the bowling alley visible to the west. An antique store, later occupied by Westwood One, was located down the block with a billiard hall, just before Mary Evelyn's Donuts. (Courtesy Culver City Historical Society collection.)

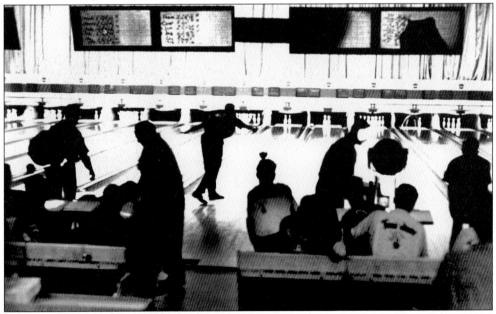

This rare interior shot of Culver City recreation shows the local bowling alley at 9524 Washington Boulevard. Bowling was popular especially in the 1950s and 1960s. Locals displayed their trophies proudly and were cheered on by friends and family. Other local bowling alleys included Jefferson Bowl, Mar Vista Bowl, King Pin, Rodeo Bowl, and the Paradise Bowling Alley. (Courtesy Culver City Historical Society Collection.)

On "Bowling Night" Culver City residents changed into their bowling shirts and headed for the bowling alley. There were tournaments, regular, and open bowing. This team bowled in downtown Culver City. In back, from left to right, are Charles R. Lugo, who retired as captain of CCPD, unidentified, and Joseph Lawless, a local printer who served on the school board and later on the city council. (Courtesy Culver City Historical Society Collection.)

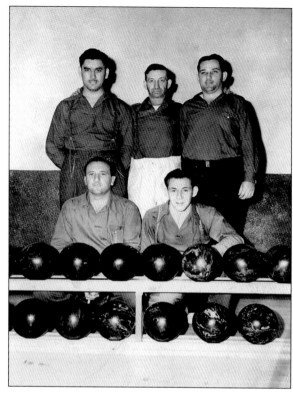

The Culver Washington "X" was broken by railroad tracks and utility poles in early times. This aerial, c. 1927, could have been taken from the Culver Hotel, looking west. The arrow on the left points to Irving Place. Culver City Grammar School was visible on the left when turning at the arrow onto Irving. (Courtesy Culver City Historical Society Collection.)

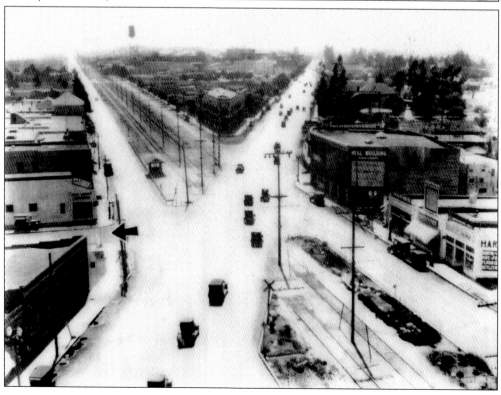

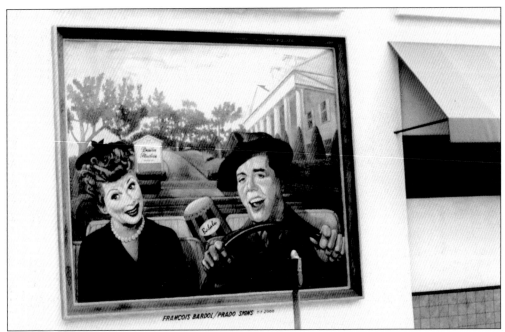

Around the corner from Washington Boulevard on Irving Place, local businessman Gus Prado commissioned a mural of Lucille Ball and Desi Arnaz, who bought the studio pictured in the background in 1956. Desilu is pictured in the background by the artist Francois Bardol. (Courtesy Cerra Collection.)

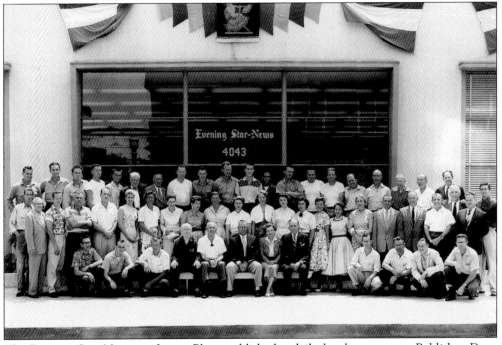

The Evening Star News on Irving Place published a daily local newspaper. Publisher Dave Duncan is shown here, front row, center, with well-read columnist Bill Fenderson, second from right. (Courtesy Culver City Historical Society.)

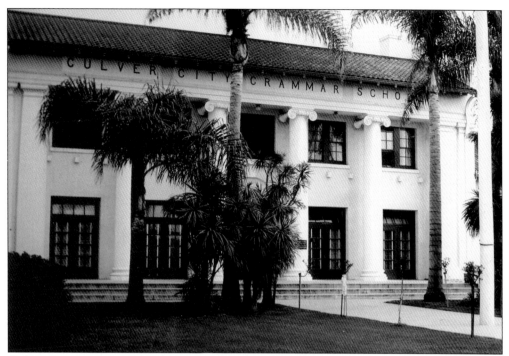

Culver City Grammar School was the second elementary school built in what became Culver City. This structure made way for the new Linwood E. Howe School, which was named for respected principal Lin Howe. (Courtesy Petrelli Collection.)

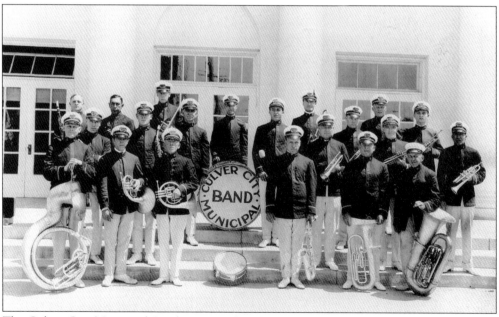

The Culver City Municipal Band is pictured in front of Culver City Grammar School. Music was important to the early city fathers. In a 1924 resolution, the trustees (now council) mentioned a music promotion fund. That same year they authorized $200 to assist the purchase of uniforms for the Culver City-Palms Band. (Courtesy Caldwell Collection.)

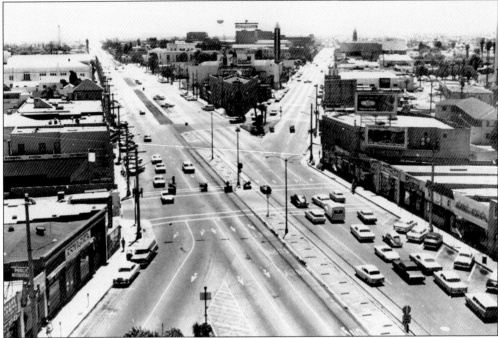

The Culver Washington "X" in the 1960s shows less clutter in the median and much more construction. The billiard hall is just visible on the left, past the antiques store. The historic Washington Building is centered with the Culver Theatre behind on Washington. Beyond is the Metro-Goldwyn-Mayer Studios, with the sign on the historic sound stages and the water tower to the left. The Hull Building appears on the right, center, cluttered with billboards, a thing of the past. (Courtesy Cerra Collection.)

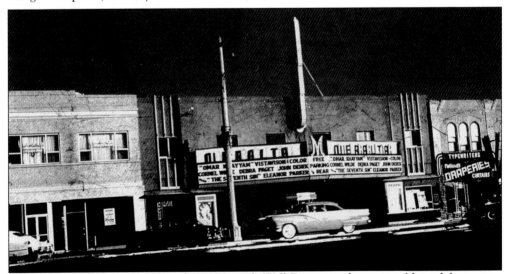

The Meralta Theatre opened in the 1920s with Will Rogers as the emcee. Named for owners Pearl Merrill and Laura Peralta, the ladies often watched movies from their second floor apartment. When the Meralta burned during World War II, the city showed movies in City Hall until the theater could be rebuilt. The redevelopment of that block included the Meralta Plaza. (Courtesy Freeman Collection.)

30

On LaFayette Place, just below Culver Boulevard, several courts have been recognized historically as the LaFayette Landmark District. The 1925 Spanish Colonial courts were built by Orlopp and Orlopp, who also constructed the Washington Building. The units have housed some noted locals, including Mrs. M.V. Bell, city attorney Don Olson, and Milford Cline, a lighting director at MGM studios who worked on films like *Showboat*. (Courtesy Culver City Historical Society Collection.)

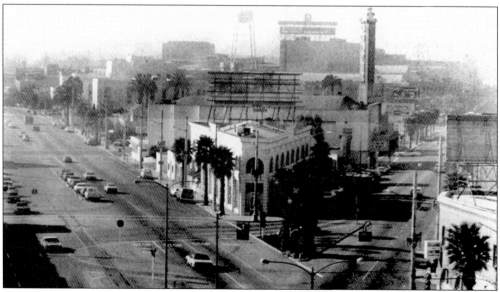

This shows the Washington Building before the sidewalks were widened. The structure designed by Arthur Scholz holds local landmark status as well as National Register of Historic Places status. Commissioned in 1926 by Charles Lindblade, it is described architecturally as Builder's Beaux Arts Classicism. Orville Clark, who designed the city hall and fire station across the street, probably served as a consulting architect on this building. (Courtesy Culver City Historical Society Collection.)

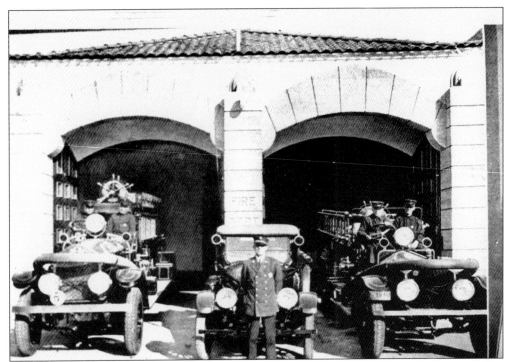

While the fire department operated on Van Buren Place, bonds were passed to construct Fire Station No. 1. Completed in 1927 on Culver Boulevard, it was the main station until the 1990s. A second station operated on McConnell in early times, in a converted home. This photo captures the working fire department the year it opened on Culver. (Courtesy Culver City Historical Society Collection.)

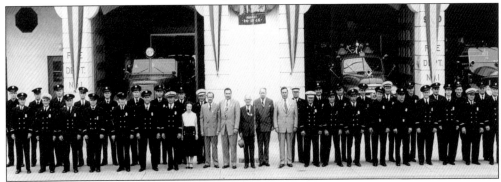

Fire Chief John Kearney's collection of historic photos included this one taken in 1952. In the center of the uniformed firefighters, councilmember Joe Sullivan can be seen on the left among the local officials, with a tall Michael Tellefson in the dark suit. This station was designed by Orville Clark and it opened just before the new city hall next door. (Courtesy Culver City Historical Society Collection.)

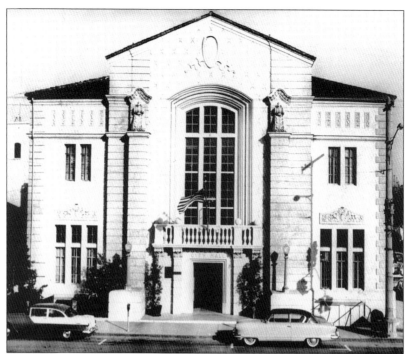

City Hall, pictured in the 1950s, was the first structure actually built to serve as a city hall. Noted architect Orville L. Clark set the tone for the downtown with his classic style. His influence could be seen next door in the fire station and in the Washington Building. The front of this 1928 city hall was used for many movies and television shows. You might recognize it from *County Hospital* with Laurel and Hardy or the *Hunter* television series. (Courtesy Culver City Historical Society Collection.)

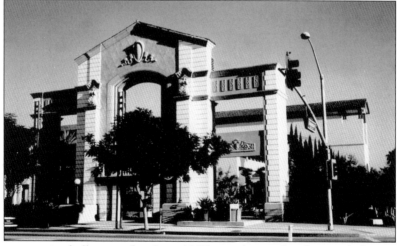

The city's newest city hall, opened in June 1995, was designed with a symbolic entry facade reminiscent of movie sets. Approaching city hall, one sees examples of the public art mandated by ordinance in Culver City. There are several fountains, and the builder of the quotation walls used bricks from the earlier structure. A conference room was dedicated to Mayor Emeritus Dan Patacchia, and the main meeting room was renamed in memory of a former mayor as the Mike Balkman Council Chambers. (Courtesy Cerra Collection.)

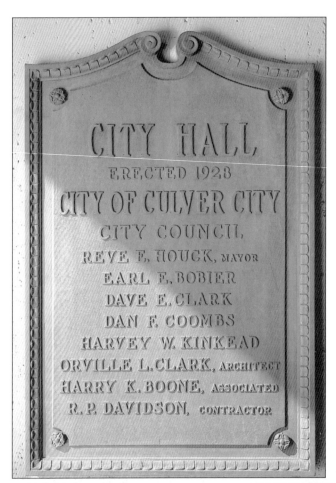

This original plaque was rescued from the 1928 city hall to grace the entry facade of the new 1995 structure. Mayor Reve Houck financed the first municipal bus. Local contractor and councilmember Dan F. Coombs and his family have been recognized with a street and a park named for them. There is also a new plaque for the 1995 city hall dedication. (Courtesy Cerra Collection.)

The 1940 Moderne-style Gateway Station Post Office is a block west of city hall, on Culver Boulevard. It has historic recognition status. Although documentation is slight, local lore tells that the station was named Gateway to allude to a "gateway to the stars" in this movie town. The post office contains a mural painted by artist George Samerjan in 1941. (Courtesy Cerra Collection.)

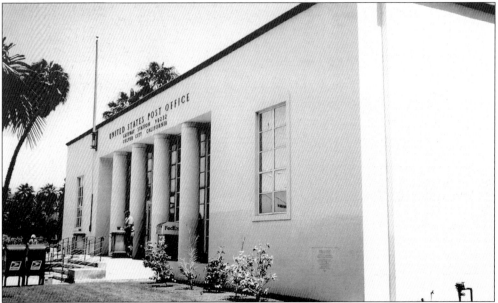

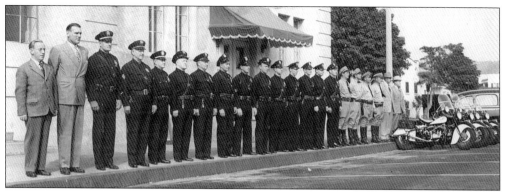

The Culver City Police Department headquarters is pictured here when it was housed in the 1928 city hall. This Duquesne entry is behind many of "Culver City's finest." In the history of the city, the police department has always been centrally located in downtown Culver City. (Courtesy Cerra Collection.)

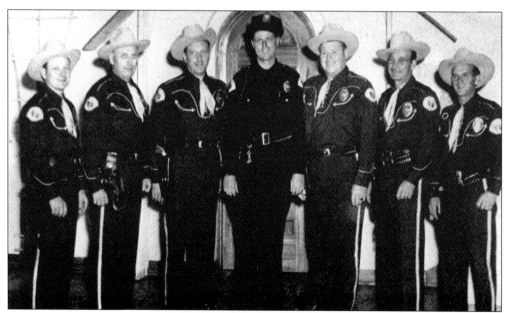

Ron Perkins, center, was instrumental in forming the volunteer Culver City Mounted Police Reserve in 1948, which was an outgrowth of a city ordinance. The mission of the 32-member "Mounted Posse" was to provide an emergency unit of men to assist the City of Culver City and the County of Los Angeles in a disaster. (Courtesy Culver City Historical Society Collection.)

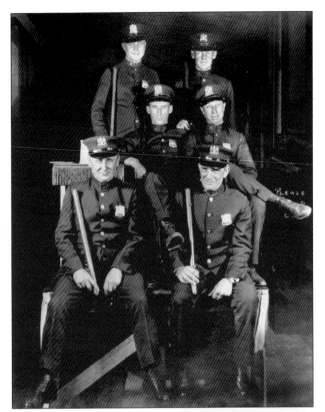

William Coombs was chief of police during the 1920s. He is shown here, on the left, with some of his men. His brother Dan Coombs was a local contractor and served as one of the early trustees (now councilmember) of the city. (Courtesy Culver City Historical Society Collection.)

The Culver City Police were featured on reality radio as *Nightwatch* unfolded to thrilled local listeners following police cases as they happened. The show, which might start with a call at "the desk," followed the real life police in action. Originators Donn Reed and local officer Ron Perkins took it to television too. Note the old switchboard manned by C.R. Lugo. (Courtesy Cerra Collection.)

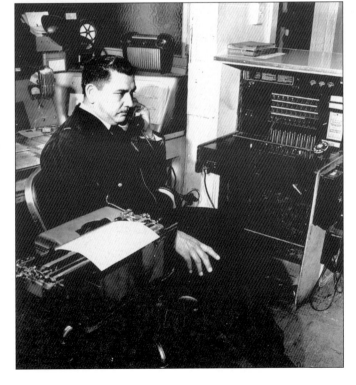

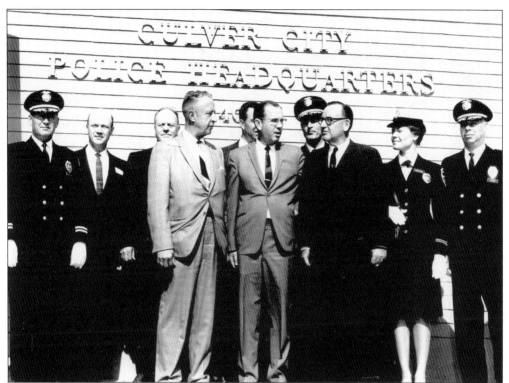

County Supervisor Kenneth Hahn was a frequent presence in the city. He is flanked by Gov. Edmund G. "Pat" Brown, right, and Police Chief Eugene Mueller, left, at a dedication of the new police headquarters in 1966. Also shown, from left to right, are (back row) Curtis Walter, C.A.O. Robert Bailey, Councilmember James Astle, Jan Mennig, Ron Perkins, Barbara (Mrs. Ron) Perkins, and Ray Lang. (Courtesy Culver City Historical Society Collection.)

On the west side of Duquesne, the Gale home remains at 4161. According to Gladys Gale Kotsvatz, her mother and aunt were on their way out to lunch one day when they saw a big bus that said "Free Lunch-Culver City." They bought houses next door to each other. Her mother went to work for Hal Roach Studios and her father became an accountant. The children crossed the fields to Culver Grammar School. (Courtesy Cerra Collection.)

On Lucerne Avenue east of Duquesne a Mr. Brown built "The Egyptian House" for his love, an Egyptian princess. It was situated on Ballona Creek, with amenities like gold locks and secret passageways. The princess is said to have died during her voyage so the couple never lived in the local mystery house. Deteriorated, it was burned as a training exercise by the local firefighters. (Courtesy Culver City Historical Society Collection.)

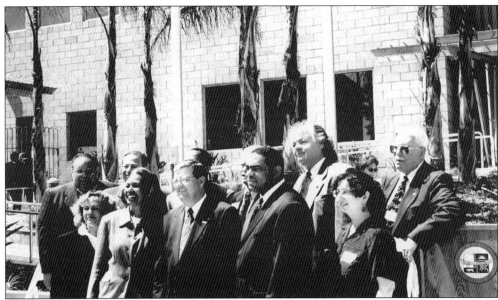

At the dedication of the new transportation facility, which replaced City Yard, the breadth of elected officials' support is apparent. City officials, shown here, from left to right, are as follows: (front row) Trudie Abrahams (Assemblymember Wesson's office), Los Angeles County supervisor Yvonne Brathwaite Burke, Transportation Director Dave Ashcraft, State Senator Kevin Murray, and Councilmember Sandra Levin; (back row) Ed Johnson (Assemblymember Wesson's office), Councilmembers Ed Wolkowitz, unidentified, Albert Vera, and Richard Marcus. (Courtesy Cerra Collection.)

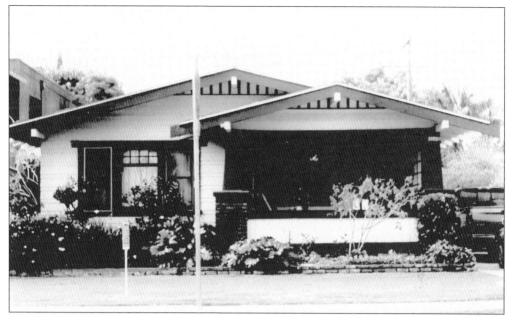

The Craftsman-style house at 4245 Duquesne is a 1920s landmark structure. Dan Coombs, a contractor and member of the city's early board of trustees, built it for his family. A park and a street both carry the Coombs name in honor of the family that continues its civic involvement. (Courtesy Cerra Collection.)

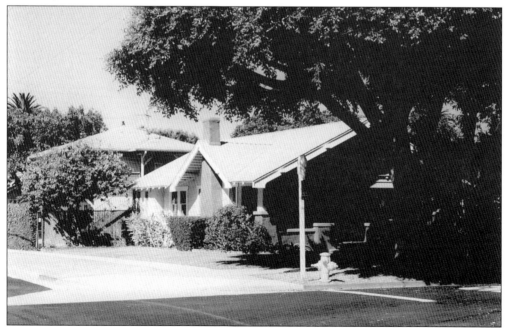

A walk along Farragut Drive yields another landmark Coombs-built Craftsman bunglow. The Pitti family bought the 1920 home on the northeast corner of Farragut. Benjamin Pitti, a well-known entertainer who performed rope and knife tricks and trained and rode horses, raised his family in this house. Across the street is Judge Emmons' Colonial Revival house, which is rated historically significant. (Courtesy Cerra Collection.)

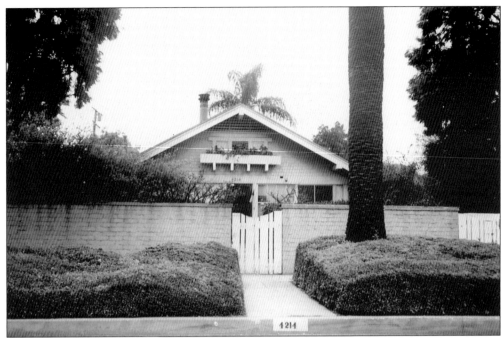

Another block west, a slumpstone wall hides the 1913 Cereghino house at 4214 Madison Avenue. The family lived within the walls of the 200-square-foot corner lot in a small Craftsman home rated historically significant. Camillo Cereghino was a principal of the company that developed tract 1775, known as Washington Park. Cereghino and his wife donated space for library and recreational purposes in the city. (Courtesy Cerra Collection.)

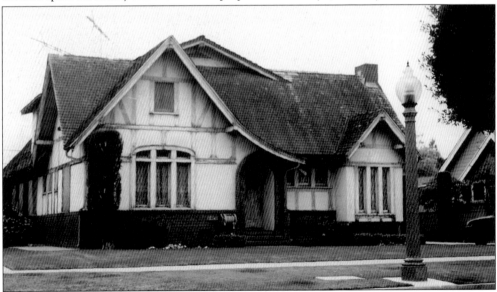

The English Tudor Revival at 4155 Madison is a historically significant structure. Built in 1926 at 3840 Delmas Terrace, it was moved in 1965 to Madison Avenue. Prior owner Adolph Steller was one of the owners of Steller Bros. & Skoog Hardware, which has been a presence on Main Street since 1923. Steller was the president of the Culver City Chamber of Commerce in the 1940s. (Courtesy Cerra Collection.)

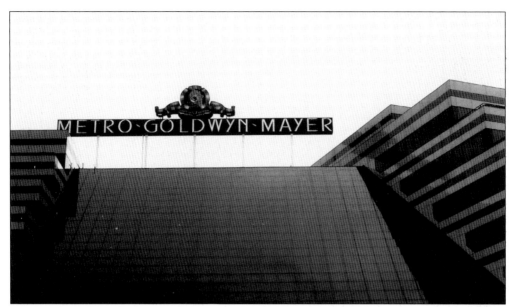

Built as the Filmland Corporate Center in 1985, Maxwell Starkman's award-winning design offered 300,000 square feet of office space and a grand atrium covered by 10,000 square feet of glass. The restaurant designer was Stan Abrams. The historic MGM sign was relit in 1987 on top of the building with help from MGM star Gene Kelly and legendary Leo the Lion. The nearly 15-ton sign and supports were removed in 1992 when MGM/UA moved to Santa Monica. (Courtesy Cerra Collection.)

Grant Avenue once led from Madison Avenue to the MGM East Gate. Pictured here, the street passed the mortuary and the Thalberg Building to the famed gate. At one time cars could turn right onto Ince Way to return to Washington Boulevard. The streets were vacated in the 1990s as Sony Pictures developed the mortuary site into the Thalberg annex and the rest of the block into Thalberg Gardens' executive parking lot. Nelson Mandela received the key to Culver City in the newly landscaped lot. (Courtesy Security Pacific Collection/Los Angeles Public Library.)

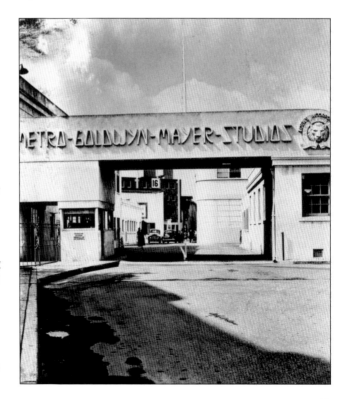

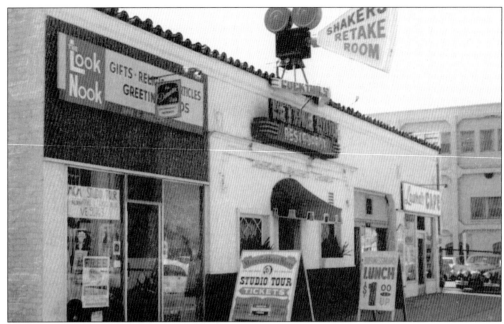

Just east of MGM Studios on Washington Boulevard, the Retake Room was known as a "watering hole" for studio workers and stars alike. At lunch or after work, one might walk from the East Gate through the parking lot to stop for a bite or a drink. Little shops on the boulevard catered to the movie trade. The building on the right was the eastern edge of the studio, with the colonnade front. (Courtesy Caldwell Collection.)

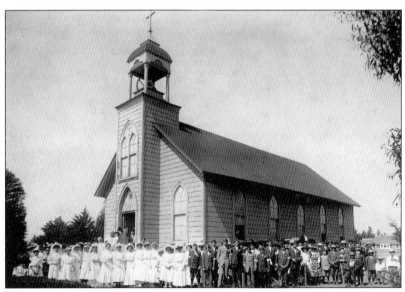

Here is a clear view of St. Augustine's Church across Washington Boulevard. St. Augustine's was the first church in what became Culver City. The 1880s mission church was built on land donated by the Figueroa family. The third and current church, built in the Gothic style, was awarded historic landmark status. Bishop Sheen officiated at the dedication in 1956. The second church now serves as the parish hall. The Culver City Historical Society marked the site in the 1990s. (Courtesy Cerra Collection.)

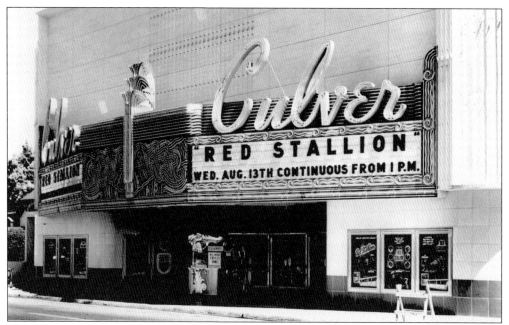

The first movie shown in the Moderne (Skouras-ized) Landmark Culver Theatre was *The Red Stallion* on August 13, 1947. In the new millennium, the city adopted a logo inspired by the Culver script above the marquee and the block lettering on the tower. The theater became the Kirk Douglas Theatre in 2003 as the Center Theatre Group entered into a 60-year lease with the Culver City Redevelopment Agency for performing arts space. The Culver script was removed by the lessee and is in storage. (Courtesy Culver City Historical Society Collection.)

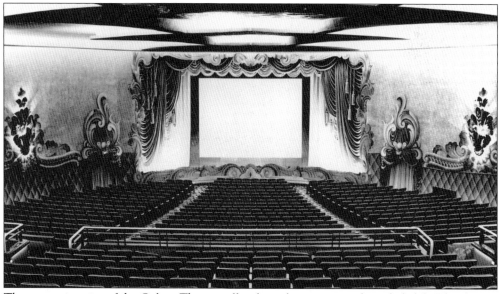

The ornate interior of the Culver Theatre offered a welcome respite from daily life. The theater manager in full tuxedo supervised ushers in white shirts, bow ties, red jackets, and gray pants with a silver stripe down the side. Sneak previews were occasional benefits and, once in a while, stars like Elvis Presley and Ann-Margret viewed a new movie like *Viva Las Vegas*. (Courtesy Culver City Historical Society Collection.)

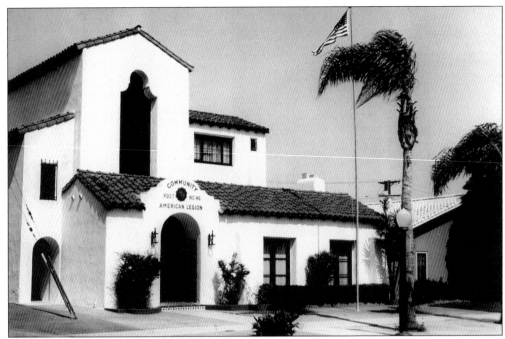

The Legion Building on Hughes Avenue was the Culver City Historical Society's fifth marking. The clubhouse, which sits over the first swimming pool in the city, was built by the American Legion Post No. 46 in 1930. The Spanish Colonial structure is ranked historically significant by the city for its "architecture, prominent builder, Don Ely, and role in the broad patterns of Culver City history." (Courtesy Culver City Historical Society Collection.)

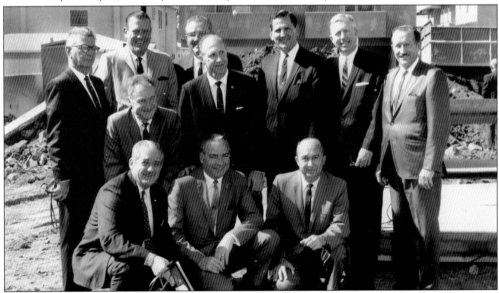

Local officials who attended the 1960s groundbreaking for a community Charter Bank, shown here from left to right, are as follows: (front row) Mayo D. Wright, Councilmember Ed Juline, and manager Joe Ellis; (middle row) Ronald "Brick" Coombs and Mayor Dan Patacchia; (back row) unidentified, unidentified, Councilmember Joe Lawless, City Clerk Ted Owings, unidentified, and Councilmember Dr. Joe "Sully" Sullivan.

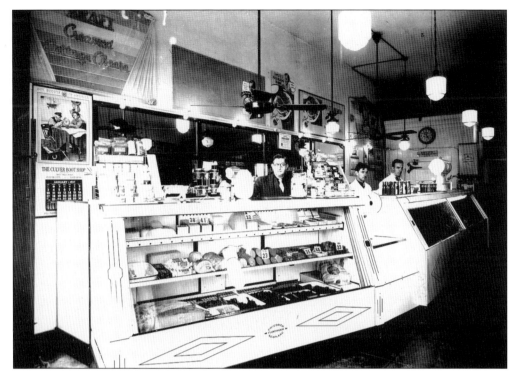

Originally from Latvia, Louis Freeman ventured west from Pennsylvania. One of his business endeavors became Freeman's Market on Washington, between Delmas Terrace and Watseka. Freeman is pictured in his grocery store in the 1930s. Freeman eventually acquired more property in downtown Culver City. (Courtesy Freeman Collection.)

As you can see, the Freeman Market offered "Zip Delivery." A young Bert Freeman, son of founder Louis Freeman, is ready to move, with his daughter and niece on the back. In those days clothes were line dried as seen behind them. Freeman Market was well known for its quality, and customers included local studio commissaries. The apples that flew in *The Wizard of Oz* came from Freeman's Market. (Courtesy Freeman Collection.)

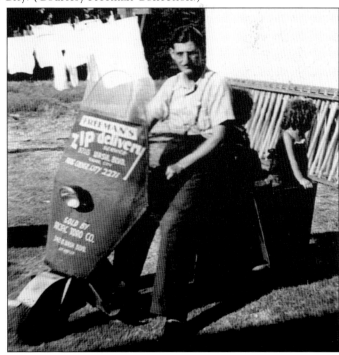

The Freeman Market eventually gave way to other retail space. These facades, pictured in the 1950s, are now improved and the businesses cater to current day needs. (Courtesy Freeman Collection.)

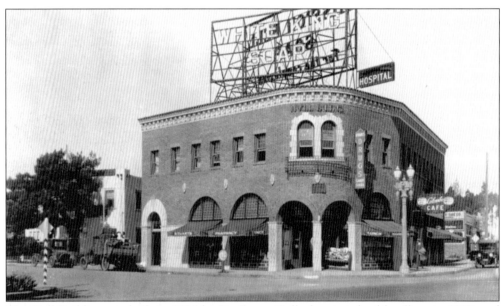

The Hull Building was built in 1925 by Dr. Foster Hull, the city's health officer in 1919, and housed the first hospital in Culver City. A victim of the Depression, the property was purchased by Louis Freeman, and it remains family owned in the new millennium. Freeman Furniture was located on the Culver side, while the entry to the pharmacy and soda fountain was on the corner. This 1920s photo shows Stuart Pharmacy, which later became Sunset Drugs. The neo-classical building has local landmark status. (Courtesy Freeman Collection.)

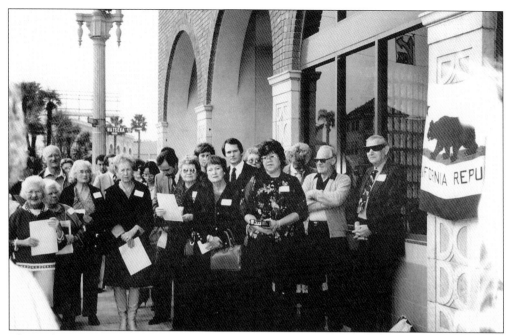

The Culver City Historical Society unveiled a marker commemorating the Hull Building as Historic Site No. 2. The plaque is covered by a California state flag, made in 1917, which was provided by Clarita Young, the *madrina* (godmother) of the society. Building owner Bert Freeman is pictured on the far right just before the dedication, surrounded by members of the Culver City Historical Society. (Courtesy Freeman Collection.)

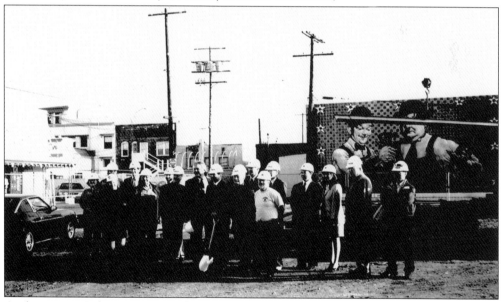

As downtown Culver City grew, the need for more parking was addressed. Shown here is the groundbreaking for the Cardiff structure. Council members and the Chamber of Commerce participated. Behind, a mural by Francois Bardol is seen on the back of Stellar Hardware. To the left, the old "Yor-Way" market, actually in Los Angeles, had become Balians Market. (Courtesy Cerra Collection.)

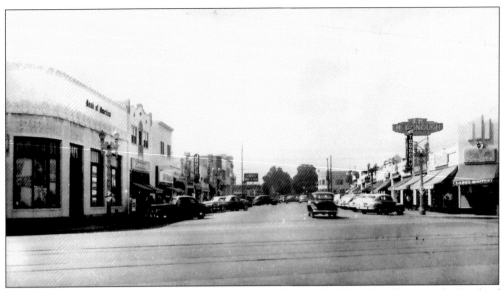

This is an image of Main Street in the late 1940s. The Bank of Italy has become the Bank of America, and J.H. McDonough Plumbing is still around, although its water heaters probably look a bit newer. Main Street remained the main shopping area until the post–World War II Culver Center was developed. (Courtesy Culver City Historical Society Collection.)

Do you remember parking meters that took pennies, nickels and dimes? This chapter has ended in Culver City. (Courtesy Culver City Historical Society Collection.)

# *Three*

# THE MOVIE STUDIOS

When Harry Culver pitched his plans for a city, he knew it needed a sound economic base such as the emerging movie industry. Because small studios like Essenay had already located nearby, it was a natural alliance.

Thomas Ince built the legendary entry to his new movie studio on Washington Boulevard in 1915, two years before Culver City was even incorporated. It became Goldwyn Studios and then Metro-Goldwyn-Mayer in 1924. Known as MGM-UA, then Lorimar, the historic MGM sign with Leo the Lion moved across the street in the 1980s where it stayed until 1992. Sony became the owner in 1990 with the studio first called Columbia Pictures and then Sony Pictures Studios, the global headquarters for Sony Pictures Entertainment. Sony renovated the 44-acre lot into a 45-acre state-of-the art studio facility.

Ince established his second major studio in Culver City in 1919. After Ince died in 1924, the sign boasted DeMille, RKO, Pathe, Selznick, Desilu, Culver City Studios, Laird International, and most recently The Culver Studios. Hal Roach Studios, often called the "Laugh Factory to the World," was located in Culver City from 1919 to 1963.

By the 1930s, the city seal read "Culver City, the Heart of Screenland." People in Culver City were proud of their movie heritage, so reading credits like "Made in Hollywood" became a thorn in the side of the local citizenry. The Culver City Chamber of Commerce printed new stationery reading "Culver City, where Hollywood movies are made." Despite a 1930s attempt to bury the hatchet between the Hollywood and Culver City Chambers of Commerce, it was not until 1991 that movies made in Culver City began to read "Filmed at Sony Pictures Studios in Culver City, California."

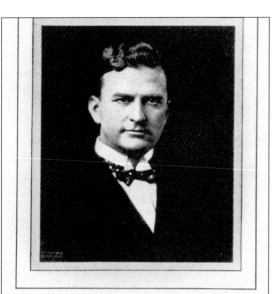

THOMAS HARPER INCE
1881 - 1924

*AS this Silver Sheet came from the press our Beloved Chief was stricken while in the midst of his arduous labors. Words cannot express the loss his associates and employes feel in the passing of their friend and leader. With heavy hearts they "carry on" the work he so ably directed for many years.*

Thomas Ince could be called the "Father of the Heart of Screenland." Harry Culver enticed the filmmaker to move his operations to Culver City, and Ince built two of the three major studios in town. He operated in partnership with Mack Sennett and D.W. Griffith at the first location and then moved back to Los Angeles while he built the second. Ince died amidst mysterious circumstances in 1924. (Courtesy Cerra Collection.)

The movie industry was a part of daily life in Culver City from early times. In the 1920s, it was commonplace to see young residents like Mary Lou Rebol and her little sister Joyce waiting on a bench near a studio back lot. Billboards, now called "product display boards," tell of upcoming movies. (Courtesy Culver City Historical Society Collection.)

Metro-Goldwyn-Mayer Studios eventually numbered 6 lots and more than 180 acres. Local businessman Louis Freeman is pictured on a visit to see Leo the Lion at the "Monkey Farm," the lot where MGM kept the animals. Freeman's Market supplied the MGM Commissary. (Courtesy Freeman Collection.)

The landmark colonnade is the backdrop for this 1928 celebration of Culver City's first bus, which began the second oldest municipal bus line in California. The colonnade, built in 1915, was the entrance to Thomas Ince's first studio in the city. It was restored as a part of the Sony Pictures Entertainment Comprehensive Plan, which was adopted in 1993. (Courtesy Culver City Historical Society Collection.)

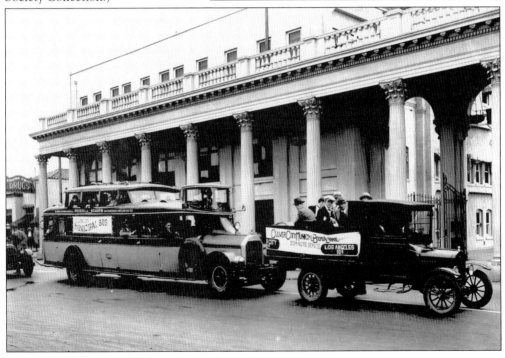

The landmark Thalberg Building opened as the "new administration building" in 1938 and remains an impressive local example of Moderne architecture. It was named by Louis B. Mayer in memory of MGM's brilliant head of production, Irving Thalberg, who was married to actress Norma Shearer. Thalberg is quoted as saying "Credit you give yourself is not worth having." Built as the headquarters of the studio where star contracts were signed, legend suggests that Spencer Tracy met Katharine Hepburn at one of the side entrances. (Courtesy Cerra Collection.)

During the MGM years, the East Gate offered entry to "more stars than there are in the Heavens." Security was managed by the gate guard, one of whom was named "Kenny Hollywood." Local autograph seekers collected signatures of the stars and even knew their license plate numbers. Vehicles entered onto "Main Street" of the studio lot that was like a city within a city, with amenities from a barber shop, newsstand, telegraph office, police and fire departments to a doctor and dentist. (Courtesy Culver City Historical Society Collection.)

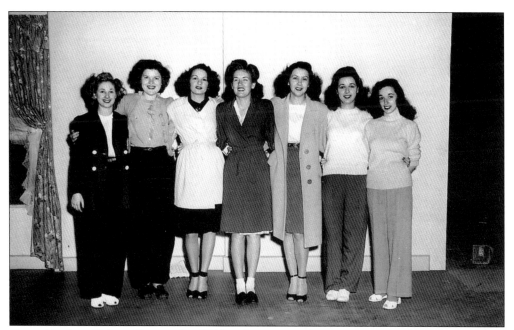

If you lived in Culver City in the 1940s, chances are that you or a member of your family worked for one of the studios, Helms Bakeries, or the aircraft industry. Jean Kleopfer is pictured (center) surrounded by her "fellow" messengers on a sound stage at MGM. During World War II, since so many young men were called overseas, many jobs opened up to young women. (Courtesy Barker Collection.)

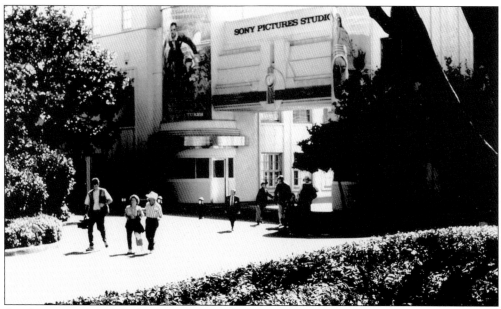

Sony's renovation of the historic studio included a new look for the East Gate, which became an interior passageway after Grant Avenue and Ince Way were vacated. Studio artists applied their crafts to enhance the walkway. In 1997 a reunion of the "munchkins" visited the lot where they had filmed *The Wizard of Oz*. (Courtesy Cerra Collection.)

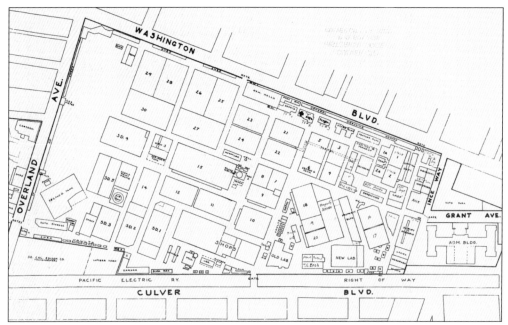

An old map of MGM shows the 28 sound stages that were eventually built on Lot No. 1. The lot was renovated in the 1990s and is now the global headquarters of Sony Pictures Entertainment. (Courtesy Cerra Collection.)

The historically significant commissary, built in 1935, is inside the East Gate at Main and First Streets. It was constructed during the time of Louis B. Mayer, who preferred to keep his workers on the lot. Mrs. Mayer even taught the chef how to cook matzo ball soup. Legendary special orders by movie stars include sauerkraut juice for Greer Garson and a certain bacon for Lionel Barrymore, while Joan Crawford required scalded plates. (Courtesy Cerra Collection.)

Stages 3, 4, 5, and 6 were constructed in 1930 as the first sound stages on the MGM lot. They were designed in a utilitarian version of the Moderne and Zigzag Moderne styles, and designated as significant historic structures by Culver City. They were used to film spectacular productions like the Busby Berkeley musicals and the Ziegfeld Follies. The historic changeable copy studio sign sits on top of these stages. (Courtesy Cerra Collection.)

The Art Deco Poitier Building once housed MGM studio chief Louis B. Mayer's private offices, which were covered in white leather. Mayer had floor switches installed to summon various aides. When Sony Pictures renovated the office, they uncovered and restored the original fireplace. The wardrobe department was once located in this historically significant portion of the 1928 structure. Note the traditional studio method of transportation—bicycles—in front. (Courtesy Cerra Collection.)

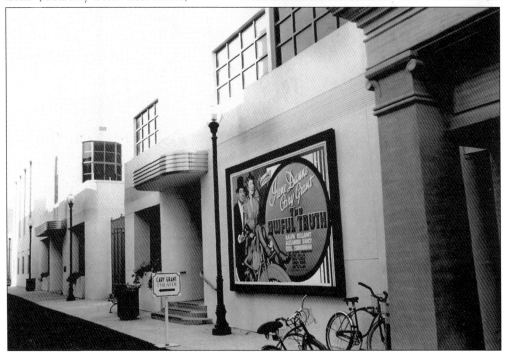

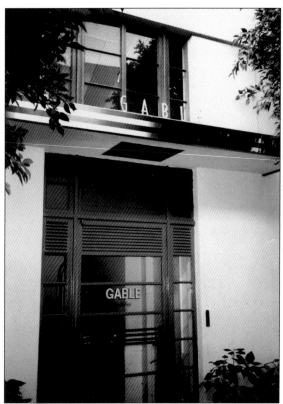

The 1937 Gable Building was constructed in the Zigzag Moderne style. Once home to the makeup and hairdressing departments, it has been designated as historically significant by Culver City. Clark Gable was a presence at the studio and had his car serviced across the street. He was known to rescue children from climbing arbors in the neighborhoods. (Courtesy Cerra Collection.)

The 1935 Streamline Moderne Hepburn Building is located on the north side of the studio lot. Once used for movie star dressing rooms, it was given significant status by the city. Lana Turner's dressing room was a corner room. Katharine Hepburn was always a favorite and the building is near the Tracy Building. (Courtesy Cerra Collection.)

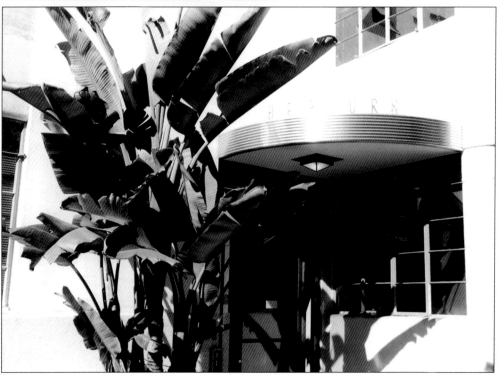

The Tracy Building, rated significant, was constructed in 1933 in part from a movie star bungalow. It has been used for offices and was the hospital on the lot at one time. It was named for Spencer Tracy, who worked on this historic studio lot but not necessarily in this building. Behind Tracy is Washington Row, originally two stories of small dressing rooms, designed for women on one floor, men on the other, separated by a matron. Note the traditional studio golf cart parked in front. (Courtesy Cerra Collection.)

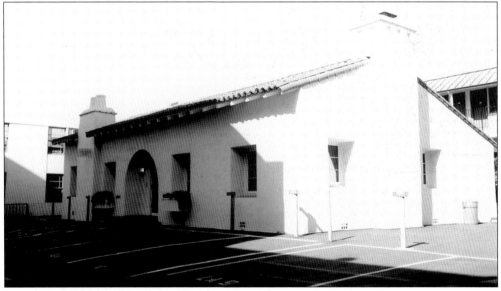

The Crawford Building is the only example of Spanish Colonial period–style architecture on the studio lot. Constructed in 1927, it was once occupied by Louis B. Mayer. It was also used as a schoolhouse for stars like Judy Garland, Mickey Rooney, Elizabeth Taylor, and Roddy McDowell. Production office space is the most recent use of the building, which is rated a significant historic structure. (Courtesy Cerra Collection.)

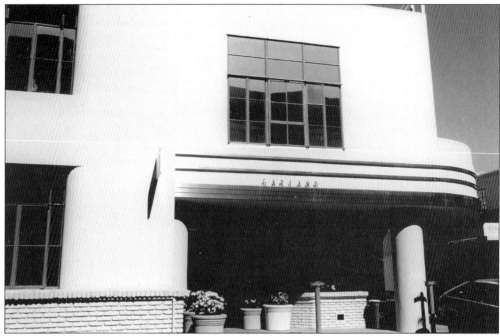

The Garland Building was constructed in 1934 in part from an existing movie star bungalow. The two-story Moderne structure is ranked significant by Culver City. It has been used for the production offices and the wardrobe department and is just east of the old rehearsal halls where Gene Kelly practiced. (Courtesy Cerra Collection.)

The Myrna Loy Building was constructed in 1935 in the Streamline Moderne style. Known in early times as the "Director's Building," it was also used for feature players' dressing rooms. Designated a historically significant building, it was named for Myrna Loy, who grew up nearby and attended Venice High School before she made movies on this lot. (Courtesy Cerra Collection.)

The water tower is equipped to hold up to 100,000 gallons of water. Designated as historically significant, it is a constant reminder of the presence of the studios and the concept that this lot was likened to "a city within a city." It is pictured in the background during Sony's restoration work in the 1990s. In front are typical barn-like sound stages. (Courtesy Cerra Collection.)

MGM's Lot No. 2 was located across Overland Avenue (front) from the main studio lot. It was a conglomeration of ever-changing facades designed for motion pictures. An outdoor tram took studio workers from Lot No. 1 to Lot No. 2 on a regular basis. Note the varied types of sets, from a dock to a railroad station to New York City's eastside streets. (Courtesy Culver City Historical Society Collection.)

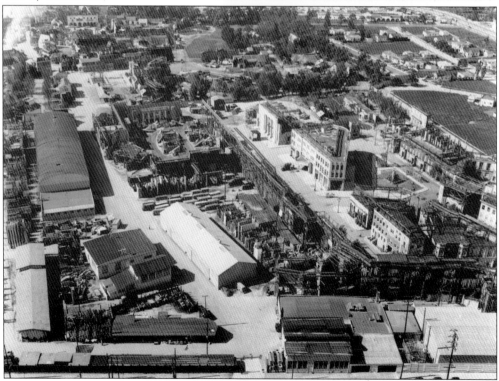

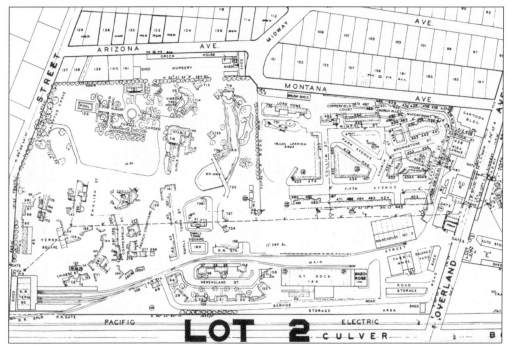

The map of MGM's Lot No. 2 shows its location within the city, bounded on the south by Culver Boulevard, Elenda Street on the west, and Overland Avenue on the east. Residential properties were on the north. After the lot was sold in the late 1970s, it was developed into housing (Studio Estates, Palm Court, and Studio Royale). In 2003 the new Senior Center was dedicated at Overland and Culver. (Courtesy Culver City Historical Society Collection.)

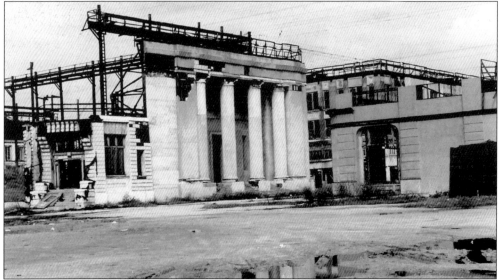

Inside MGM's Lot No. 2 in 1978 one could see the remnants of the outdoor sets prior to the demolition of the lot. The formerly used columns and structures had lines overhead to accommodate the sets to make night scenes during the day. Stanley Donen, director of *Singin' in the Rain*, mentioned in a PBS special that the crew had to work around Culver City residents who liked to water their lawns when they were filming the rain scenes. (Courtesy Cerra Collection.)

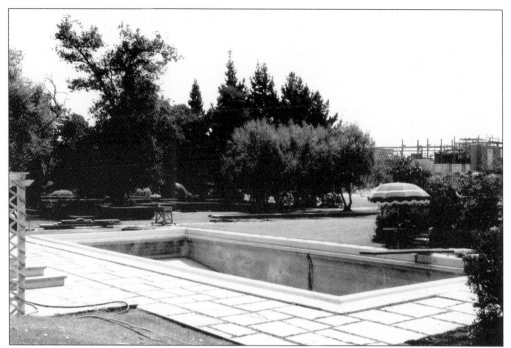

This swimming pool on MGM's Lot No. 2 was built for Esther Williams. In the background, backs of the facades are apparent. The famous aquatic actress filmed many of her movies across the street on the main lot on Stage No. 30, which had a tank with a hydraulic lift. That stage is still in use today. (Courtesy Cerra Collection.)

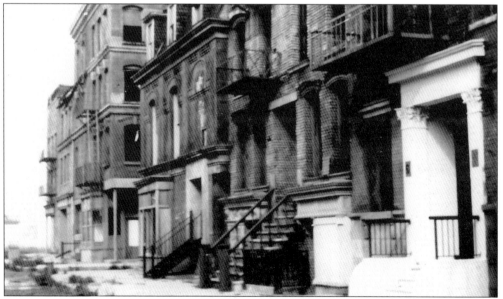

Part of MGM's Lot No. 2, with New York City eastside and brownstone streets is shown here, c. 1978. The buildings were all fronts. This was just prior to the demolition of the lot. One can see the deterioration of the sets and the weeds pushing through the streets. The garage used for the St. Valentine's Day Massacre in *The Al Capone Story* was at the end of the street. (Courtesy Cerra Collection.)

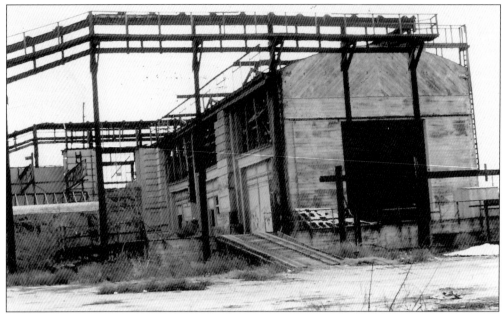

The railroad station on MGM's Lot No. 2 was used in many movies, including *The Outrage* with Paul Newman. The tracks actually went to Culver Boulevard where the studio could receive shipments. Part of the train housed on the lot was seen in *How the West Was Won*. (Courtesy Cerra Collection.)

During the 1960s, the television program *Combat* was filmed at Metro-Goldwyn-Mayer. It starred notable actors like Vic Morrow, Rick Jason, Pierre Jalbert, and Dick Peabody. Pictured here is an old village that was "re-designed" to represent a "bombed out war town" for their use. (Courtesy Cerra Collection.)

You may recognize this facade on Lot No. 2 from *National Velvet*. Young stars included Mickey Rooney, Elizabeth Taylor, Angela Lansbury, and Juanita Quigley. Ms. Quigley grew up in Culver City as a child star but later joined the convent. She taught speech classes at a nearby parochial high school as Sister Quentin Rita. (Courtesy Cerra Collection.)

Part of another outdoor set on MGM's Lot No. 2, this bridge was used for *Gigi*, with Maurice Chevalier and Leslie Caron. It was also seen in *The Three Musketeers* and was changed as needed for other movies. (Courtesy Cerra Collection.)

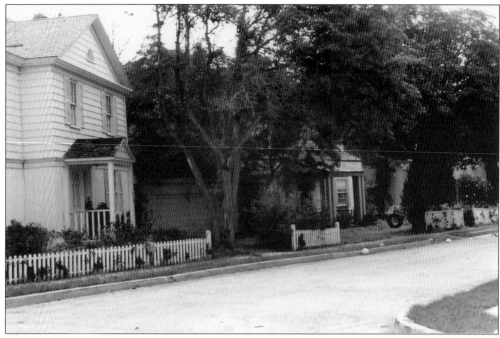

Andy Hardy Street was made up of Peter Lawford's home in *Little Women*, Frank Sinatra's home in *Some Came Running*, and, of course, Mickey Rooney's home and that of his girlfriend Polly in the *Andy Hardy* series. There was a grey brick house from *Father of the Bride* with Spencer Tracy and Elizabeth Taylor, and James Stewart and June Allyson's home in *The Stratton Story*. (Courtesy Cerra Collection.)

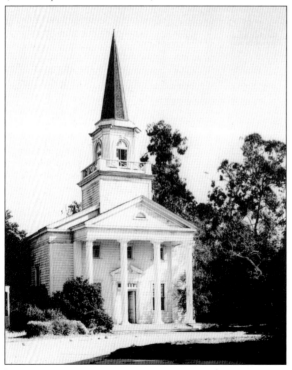

This white chapel was situated at the end of Andy Hardy Street on MGM's Lot No. 2. It was seen in *Sweet Bird of Youth*. Just down the street, there was a grey brick house used in *Father of the Bride*. (Courtesy Cerra Collection.)

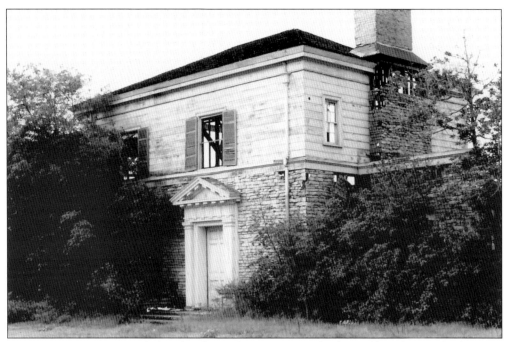

Used in many movies, and thereby changed often to suit the latest film, this was built as the Lord home for *The Philadelphia Story*, with Katharine Hepburn, James Stewart, and Cary Grant. It was also used for pictures like *High Society* with Grace Kelly, Bing Crosby, and Frank Sinatra. This is another 1978 photo just prior to demolition. (Courtesy Cerra Collection.)

This gazebo, built for *Under the Rainbow*, could be seen on MGM's Lot No. 2 in the center of the town square. Filming took place for that movie on city streets in downtown Culver City too. (Courtesy Cerra Collection.)

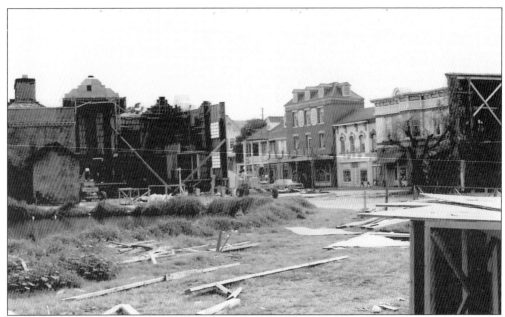

This photo was taken in 1978 of MGM's Lot No. 2. It is a good example of how the facades look from the front and the back of an outdoor set. One of the town square sets is in the distance. The little streets and the square could be finished to look like any Town Square, U.S.A. (Courtesy Cerra Collection.)

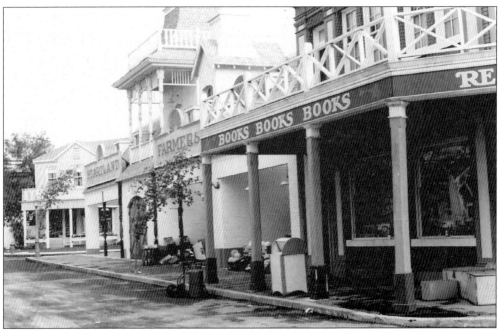

Remember the town squares in *Andy Hardy*, *Huckleberry Finn*, and *Singin' in the Rain*? They were filmed here on Lot No. 2. There were actually two town squares on this lot. Other interesting uses of this back lot varied from a Verona set to a small Chinese street for *The Good Earth* to a warehouse used to house the elephants in *Jumbo*. (Courtesy Cerra Collection.)

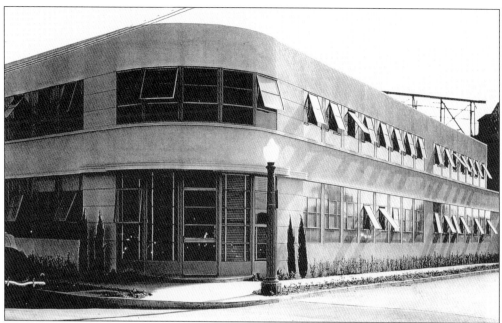

The MGM Cartoon Studio was located at the north edge of Lot No. 2 next to Montana Avenue, a residential street. Hanna and Barbera, the creators of Tom and Jerry, got their start right there. In *Anchors Aweigh*, Gene Kelly danced with Tom and Jerry, but MGM's lack of interest in cartoons sent the talented cat and mouse duo to Hollywood. The cartoon studio operated from 1937 to 1957. (Courtesy Culver City Historical Society Collection.)

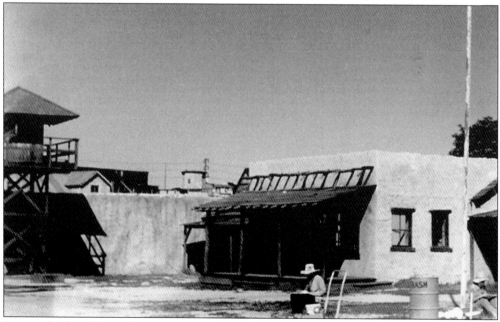

Just inside the old, wooden green-painted fence on MGM's Lot No. 3 was a fort used for *The Gunslinger* and the *Rawhide* television series. The inside of the fort is pictured here in 1971, just before the huge 65-acre lot was demolished. The Lakeside Villas development replaced this portion of the largest lot. (Courtesy Cerra Collection)

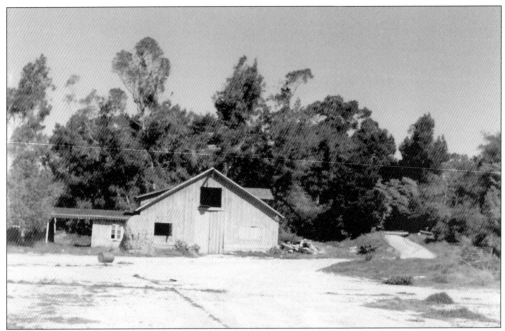

This barn facade was located on MGM's Lot No. 3. Although it looks like a full building, it consisted of only the front, which could be changed depending on a movie's need. The inside shots were filmed on a sound stage on the main lot. (Courtesy Cerra Collection.)

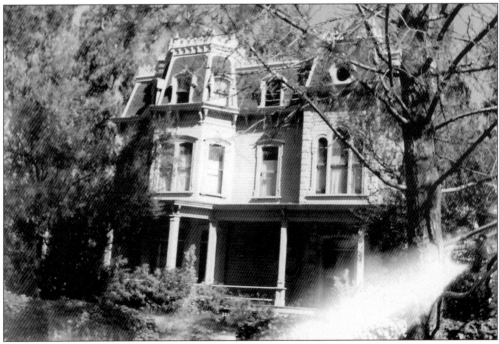

Lot No. 3's St. Louis Street in its heyday, with its carefully manicured lawns, was seen in *Meet Me in St. Louis*, starring Judy Garland; *Cimarron*, starring Maria Schell and Glenn Ford; and *The Unsinkable Molly Brown*, starring Debbie Reynolds and Harve Presnell. (Courtesy Cerra Collection.)

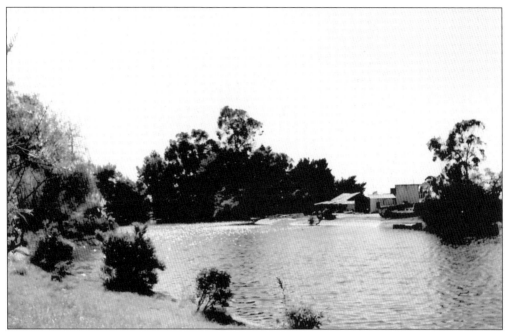

The capacity of this man-made lake on MGM's Lot No. 3 was approximately 7 million gallons of water. The jungle area behind appeared in films like *Tarzan*, *Raintree County*, and the TV series *Combat*. Rumor has it that many who worked in this area were a happy bunch. Could it have been the marijuana on the island? This location was developed into housing named Raintree with a reconfigured lake. (Courtesy Cerra Collection.)

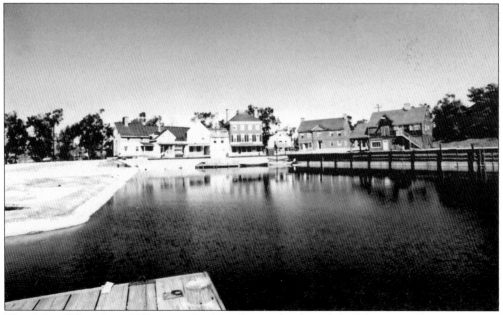

The Salem Waterfront Village was built at the north edge of the lake on MGM's Lot No. 3. Scenes from movies like *All the Brothers were Valiant*, *I'll Cry Tomorrow*, and *Advance to the Rear* were filmed here. The *Cottonblossom* from *Showboat* and the boat from *Tugboat Annie* were anchored at the far end by the village. (Courtesy Cerra Collection.)

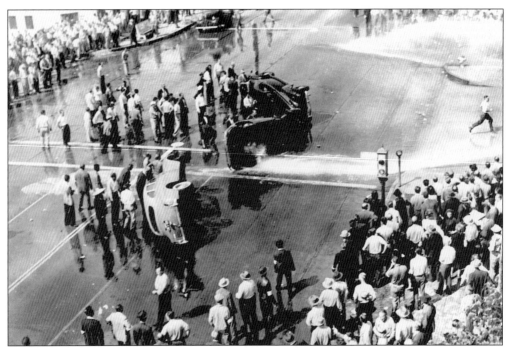

Although Culver City is known as "The Heart of Screenland," the city suffered from studio strikes. This is an unfortunate picture of the violence that could sometimes occur, taken during the 1940s. (Courtesy Culver City Historical Society.)

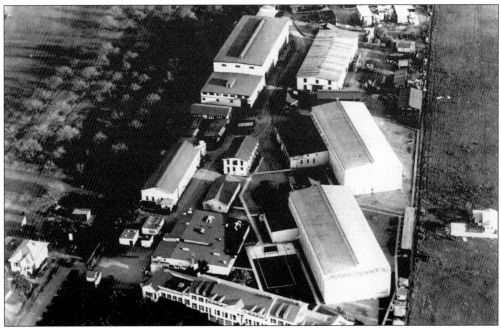

Thomas Ince Studio is pictured in 1922. Built in 1919 as Ince's second studio in Culver City, it was located at 9336 Washington Boulevard, with "emerging" neighborhoods from Ince Boulevard east and Van Buren Place west. A pool and the original silent film stages were located behind the administration building. (Courtesy Cerra Collection.)

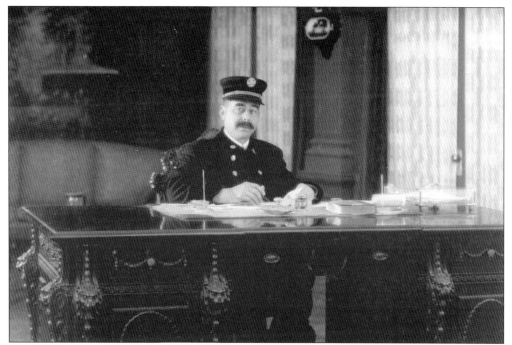

This 1922 photo shows Fire Chief L.B. Minnick at his desk at the Thomas Ince Studios. In the early days of Culver City, the studios often provided fire support for the city. This chief acted as a volunteer, running up the street when he heard the city siren and recruiting volunteers along the way. (Courtesy Petrelli Collection.)

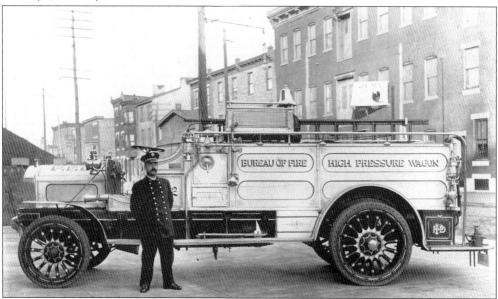

Studio Fire Chief Minnick posed on the back lot of Ince Studios. The biggest fire in the early days occurred in 1925 when a sound stage, paint shop, and carpentry shop burned on the lot. Volunteers reportedly received $4 for a 16-hour day. Names of the first volunteers included Tucker (Ernest and William), Burns, D'Arcy, Barton, Wilson, Stark, Scott, Kane, and Rich. (Courtesy Petrelli Collection.)

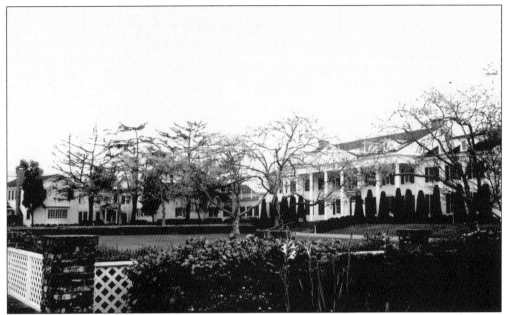

After Ince's death in 1924, the studio became known as DeMille Studios, RKO, Pathe, Selznick, Desilu, Culver City Studios, Laird International, and then The Culver Studios. The Colonial Revival-style mansion and Ince appendage to the left have been designated as landmark structures by the City of Culver City. (Courtesy Cerra Collection.)

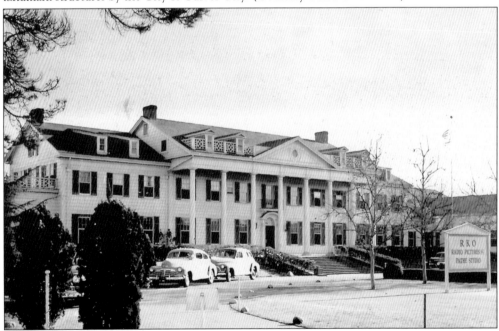

In the 1940s the sign on the front of the studio read RKO, with Radio Pictures and Pathe Studio underneath. RKO, which stands for Radio-Keith-Orpheum, controlled the studio for 30 years. This studio made silent movies, classic "talkies" like *Gone with the Wind, Citizen Kane, A Star is Born, Spellbound, Rebecca*, and, more recently, films like *E.T., Raging Bull, City Slickers*, and *Stuart Little*. (Courtesy Cerra Collection.)

Can you imagine the ghost of Thomas Ince or Gloria Swanson standing at the top of the stairs in the administration building of The Culver Studios? This would be their view downstairs. Year after year, although unsubstantiated, there are claims by studio workers that they feel the ghostly presences of both. (Courtesy Cerra Collection.)

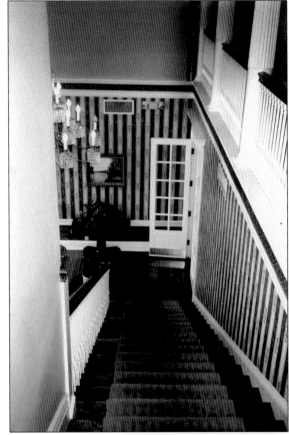

Thomas Ince built his office on the second floor of the mansion building. This view captures a portion of its rich wood, worked to give the impression of being in a boat. Note the mural at the far end. (Courtesy Cerra Collection.)

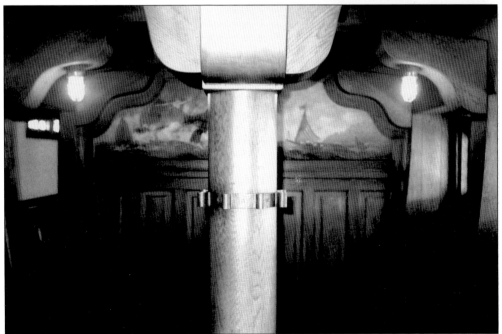

Another view of Thomas Ince's office on the second floor of The Culver Studios landmark mansion building showcases the warm, dark wood and fireplace. (Courtesy Cerra Collection.)

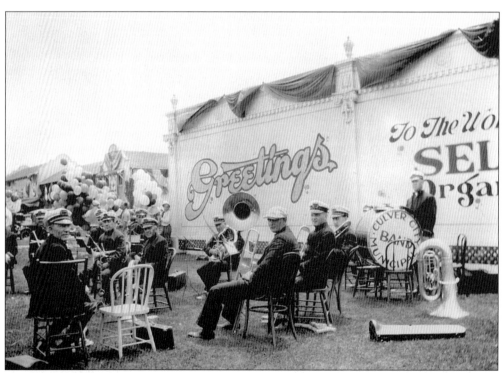

Culver City had a municipal band in its early history. The band is playing on the front lawn of the Selznick Studios in the late 1930s. (Courtesy Caldwell Collection.)

The DeMille Theatre at The Culver Studios was built in 1927 in the Colonial Revival style. It has been designated by the city with landmark status. The small theater, which showed dailies and special screenings, was dedicated to the famous producer in a ceremony on July 27, 1984. (Courtesy Cerra Collection.)

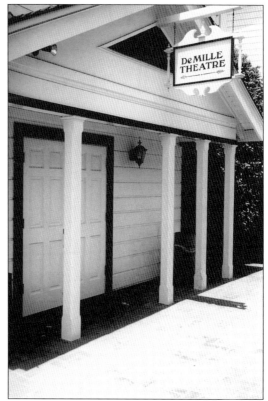

Behind the administration building at The Culver Studios you see charming bungalows transformed into office space. Studio Operations is located within this building. Note the well-cared-for landscaping, which has become a Sony tradition at both studio lots in Culver City. (Courtesy Cerra Collection.)

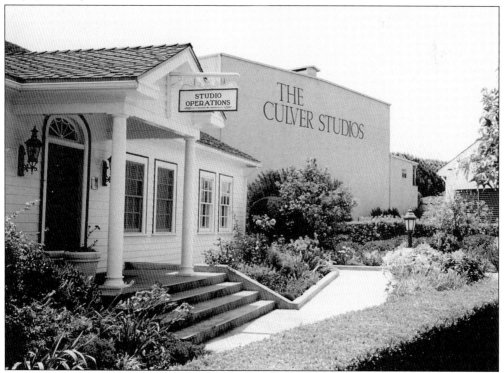

Four buildings on The Culver Studios lot were given significant status by the City of Culver City—bungalows S,T, U, and V. Building S was constructed in 1935 in the 1920s Colonial Revival style. It is a double bungalow probably occupied by stars for movies like *Gone with the Wind* in the early days. Production office space is the primary use today. (Courtesy Cerra Collection.)

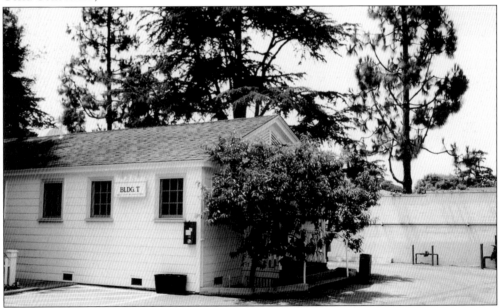

Building T is the second historically significant building on The Culver Studios lot. It was built in 1938, with a slight variation on the 1920s Colonial Revival theme. Originally housing stars' dressing rooms, it retains its original integrity but has been converted to office space. Oral tradition on the lot maintains that Olivia De Haviland used this space. (Courtesy Cerra Collection.)

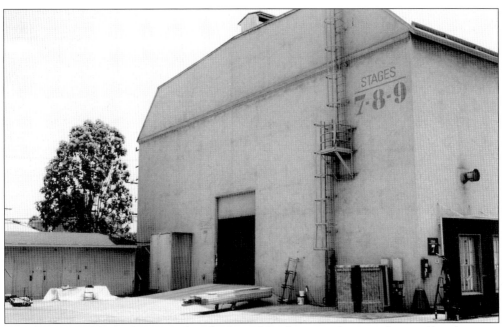

Sound stages are like big barns, ready to be dressed for the next television show or film. A variety of television shows were filmed on this studio's sound stages and the "40 acres" back lot behind. They included *The Andy Griffith Show, Hogan's Heroes, The Untouchables, The Adventures of Ozzie and Harriet, Lassie, Gomer Pyle,* and *Peyton Place.* (Courtesy Cerra Collection.)

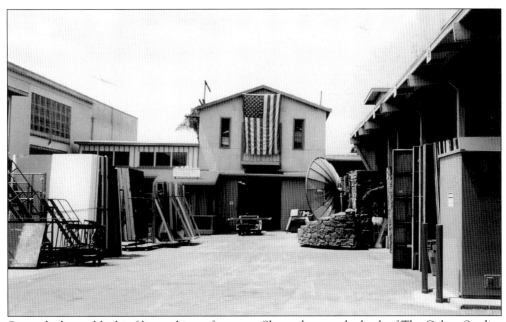

Scene docks are like big filing cabinets for props. Shown here at the back of The Culver Studios lot is a typical scene dock, with warehouse space to the left. At one time, the studio had a 29-acre back lot, referred to as the "40 Acres," where some of this might have been stored. (Courtesy Cerra Collection.)

Within the scene dock and set construction area on the lot of The Culver Studios are remnants of old movies. On the back lot, old sets, including those from *King Kong*, were burned to simulate the "Burning of Atlanta" for *Gone with the Wind*. The church/hospital had a beautiful window that is still stored in this space. (Courtesy Cerra Collection.)

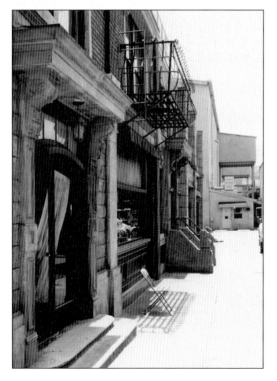

Although there is no longer a back lot like the old "40 Acres," The Culver Studios has some facades on the lot for filming use. Facades are pictured on the left, with sound stages in the distance. (Courtesy Cerra Collection.)

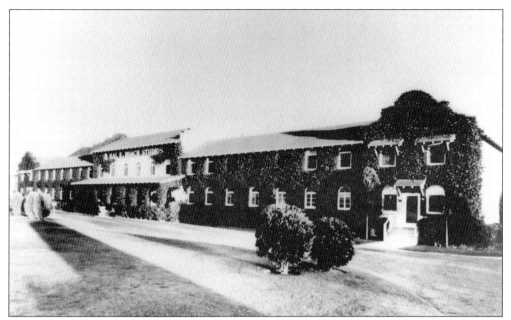

Too much red tape in Los Angeles sent Hal Roach to Harry Culver. Culver found the perfect location for the Hal Roach Studios in Culver City at Washington and National Boulevards. This studio was the third major studio in Culver City, and the only reminder of its existence (1919–1963) is a small marker for the "Laugh Factory to the World" in a small park. (Courtesy Culver City Historical Society Collection.)

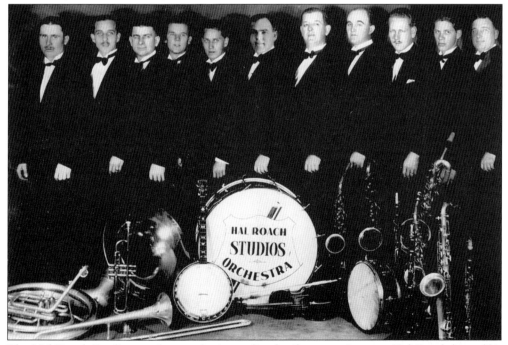

The Hal Roach Studios was known for its quality family entertainment. Hal Roach himself is pictured in the center, above the drum, with the Hal Roach Studios Orchestra. As with the other studios, Hal Roach provided jobs for many locals. (Courtesy Caldwell Collection.)

The First Motion Picture Unit (FMPU), begun by Jack Warner, was stationed at Hal Roach Studios during World War II. Roach allowed the use of his studios for the making of training films by industry professionals from cameramen to actors. They flew miniatures in Baldwin Hills. (Courtesy Robert Elliott Collection.)

The Willat Studios, owned by brothers of the same name, was just east and across the street from the Thomas Ince studios. The building was moved in the 1920s to Carmelita Drive in Beverly Hills, where it still serves as a residence. Other familiar small studios nearby included Essenay and Kalem. (Courtesy Culver City Historical Society Collection.)

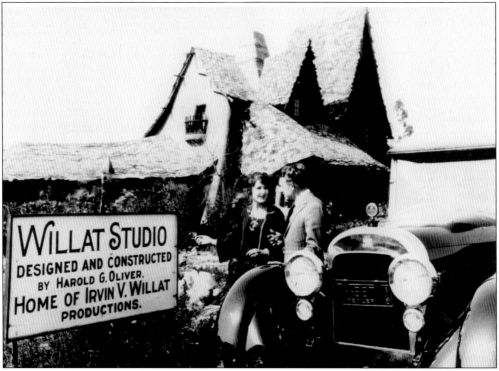

*Four*

# EAST SIDE, WEST SIDE

Rancho La Ballona ended at what is now Ince Boulevard. The Higueras' Rancho Rincón de los Bueyes (cattle corner) began there and moved east from that point. The eastern portion of the city is full of history, which includes the first industrial business, Western Stove, at the edge of what became the first industrial tract, the Hayden Tract. The eastern stretch of Washington Boulevard hosted many a commercial venture, including nightclubs with famous Las Vegas–type acts, restaurants like the King's Tropical Inn, and, of course, the Helms Bakery. The translation of La Cienega Boulevard offers insight into the lack of recorded history at the far eastern tip: La Cienega means "the swamp."

Although Culver City only measures about five square miles, it is far from square as evidenced by the long arm of Washington Boulevard reaching to Walnut, the street just before Lincoln Boulevard. There has been great speculation about why this "anteater" piece came to be. Some were convinced that it was because of the pari-mutuel betting that took place at the dog racetrack at that end. Gambling existed early on, but it is probably more reasonable to simply accept that Harry Culver, the businessman, knew the value in collecting taxes from a commercial district leading from the big city to Abbot Kinney's resort of Venice.

The western section of the city is laden with interesting memories, beginning with Overland Avenue's post–World War II development like Culver Center, and farther west, Fatty Arbuckle's Plantation Café, La Ballona School, the Rollerdrome, the winter quarters of the Al G. Barnes Circus, and many businesses including night spots lining the boulevard to Walnut. That area also houses many residents who have Los Angeles mailing addresses, but they belong to Culver City.

Culver City began as 1.2 square miles and grew to almost 5 over the years. These bits and pieces, numbering 42, explain why the city has such an irregular shape.

Western Stove opened in 1922 on Hays (now National Boulevard) on a portion of Rancho Rincón de los Bueyes. It signaled the beginning of industry in Culver City. In 1945, Culver City Chamber of Commerce president Adolph Steller helped New York glass manufacturer Sam Hayden plan his industrial tract. The tract map was filed with the county in 1946. This mid-1950s photo depicts the Hayden Tract, a source of jobs for local citizens. (Courtesy Cerra Collection.)

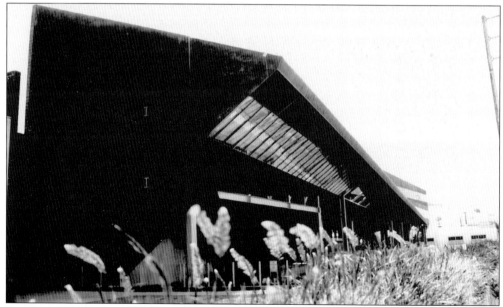

By the 1990s, the Hayden Tract cried out for redevelopment. The most striking accomplishments have been redesigned industrial space by architect Eric Owen Moss for Frederick and Laurie Smith of Samitaur Constructs. This example is part of the Smiths' Conjunctive Points project. (Courtesy Cerra Collection.)

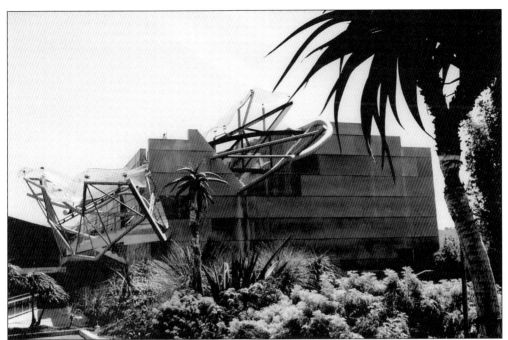

Another example of the latest alteration to the city's industrial fabric in the Hayden Tract is the work of internationally known architect Eric Owen Moss for Samitaur Constructs. (Courtesy Cerra Collection.)

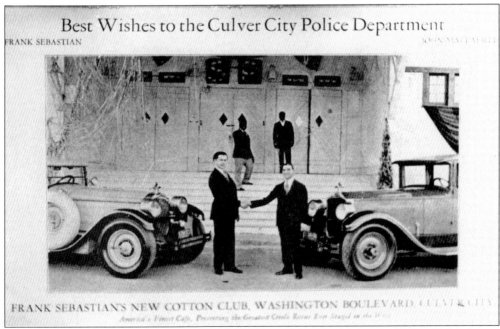

Best Wishes to the Culver City Police Department

FRANK SEBASTIAN

JOHN MATTAURI

FRANK SEBASTIAN'S NEW COTTON CLUB, WASHINGTON BOULEVARD CULVER CITY

America's Finest Cafe, Presenting the Greatest Creole Revue Ever Staged in the West

In the 1920s Culver City was fertile ground for night spots and, despite the Volstead Act, liquor flowed freely. Frank Sebastian's Cotton Club at National and Washington Boulevards was among the most famous. This ad was placed in the 1928 *Police Benefit Book*. (Courtesy Culver City Historical Society Collection.)

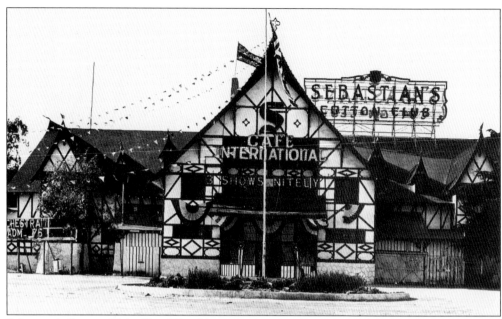

Sebastian's Cotton Club offered "Las Vegas type" acts, valet parking, three dance floors, and full orchestras. Headliners included Louis Armstrong and Lionel Hampton rivaling the club of the same name in New York. The Green Mill preceded it and Zucca's came later. (Courtesy Cerra Collection.)

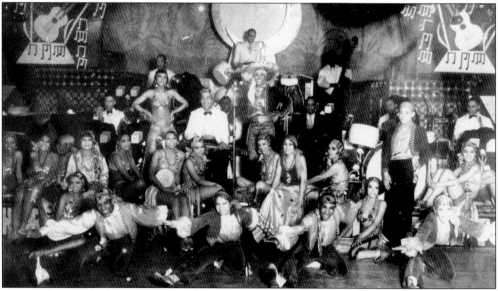

Performers on stage at Frank Sebastian's Cotton Club featured drummer Lionel Hampton, center top, c. 1931. Hampton told the *International Herald Tribune* in 1999 that he "started out at the age of 18 at the Cotton Club in Culver City, California, with Les Hite." Hampton recalled Sebastian introducing Louis Armstrong and Hampton as "the world's greatest trumpet player, Louis Armstrong, with the world's fastest drummer, Lionel Hampton." (Courtesy Herald Examiner Collection/Los Angeles Public Library.)

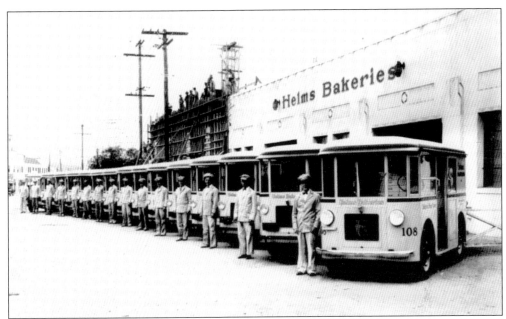

The Landmark Helms Bakery opened in 1930, and Helms Coaches were welcome sights and sounds around Southern California. Paul Helms knew his employees by their first names and local children enjoyed tours of his bakery, which is an example of the city's irregular boundaries, since it is partly in Culver City and partly in Los Angeles. The area is flourishing as the Beacon Laundry has become part of the Marks family's Helms Furniture District. (Courtesy Culver City Historical Society Collection.)

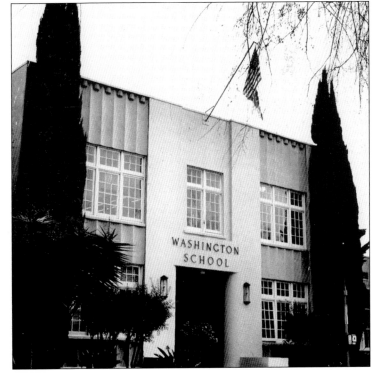

Washington School was built in 1925, but after the Long Beach earthquake it was rebuilt in the Moderne style about 1935. The school, now leased and renovated by Echo Horizon, is deemed a significant historic structure by the city. It is the oldest school structure in the city. (Courtesy Freiden Collection)

A muralist named Englander painted this mural in the WPA style in Washington School in 1936. There is one above each of two doors in the old cafeteria, on both sides of the stage. Echo-Horizon School, which entered into a long-term lease with the Culver City Unified School District for this facility, restored the murals in 1986. (Courtesy Cerra Collection.)

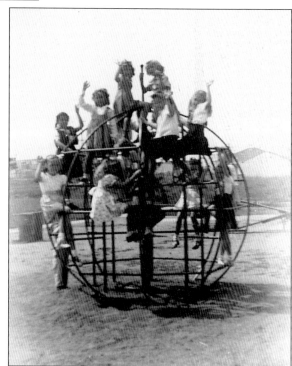

Children at play waved to the photographer on the grounds of Washington School. "Jungle gyms" were very popular in the 1940s. (Courtesy Freiden Collection.)

Bessie Freiden started the process for street tree planting on Reid Avenue in the 1940s. Celebrating her mother's success, daughter Marilyn Freiden poses in front of the new Chinese elm in the parkway in 1947. The trees had just been planted. (Courtesy Freiden Collection.)

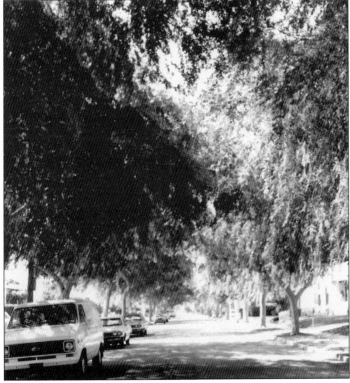

Thirty years after Bessie Freiden circulated the petition for trees on Reid Avenue, the canopy of Chinese elms offer shade and a growing sense of aesthetic beauty. Freiden also helped raise funds for lights at Culver High's Helms Field. (Courtesy Freiden Collection.)

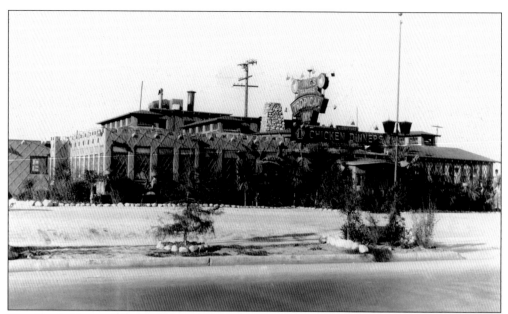

The King's Tropical Inn was famous for chicken dinners ever since John King started his business at Washington and La Cienega in the 1920s. This first structure burned to the ground in January 1930. Within a week, King had plans to rebuild on the site to seat 500. (Courtesy Cerra Collection.)

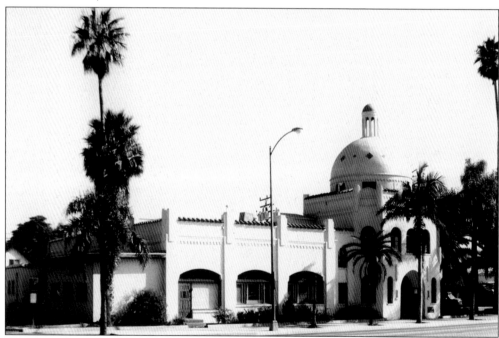

This is the landmark building that most remember as the King's Tropical Inn. It was designed by Frank Duncan and built in 22 days. It was the only example of Byzantine architecture in Culver City. After the restaurant closed, it was used as a retail shop and then a church until it was destroyed in the 1994 Northridge earthquake. (Courtesy Culver City Historical Society Collection.)

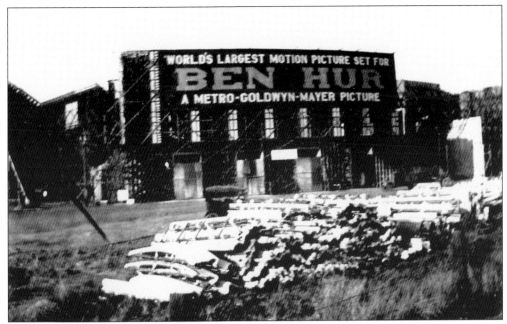

Long before La Cienega was paved, the area was used for chariot races in Ben Hur in the 1920s. Thousands of locals took the opportunity to work as extras in the movie for $3.50 plus a box lunch a day. Development took time in that area, and if you translate the word La Cienega (the swamp), it might be a clue as to why. (Courtesy Pitti Collection.)

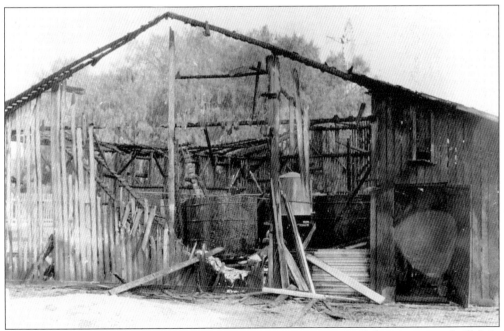

During prohibition, bootlegging became an occupation, supported by numerous "stills" in the city. Making your own liquor could be hazardous, however. This photo depicts a fatal explosion at a still on Overland Avenue on the evening of December 7, 1928. (Courtesy Cerra Collection.)

Culver Center was a post–World War II development. Culver Center Street, originally Hacienda Street, was lined with stores: clothing, a grocery, pharmacies, W.T. Grants and J.C. Penney's. Ships, pictured in 1959, was on the site of the 1880s Machado Post Office in the Saenz Dry Good Store at the corner of Overland and Washington. (Courtesy Culver City Historical Society Collection.)

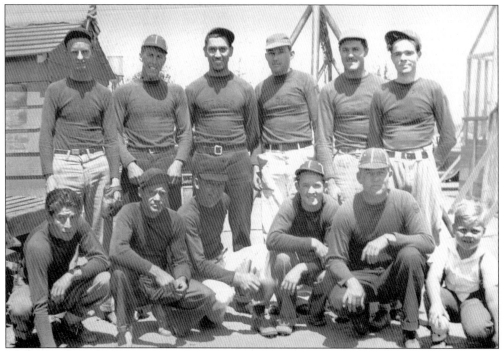

This photo looks back in time to the recreational use of the land that became Culver Center. These "boys" were playing baseball c. 1930. Sy Saenz Boxing Arena, Ed's Chili Parlor, and open space for filming movies on location operated on the site. (Courtesy Cerra Collection.)

Culver City's first public library occupied a corner of the Pacific Electric Station in 1915. The most recent library opened in 1971 on Overland Avenue. Three years later, a Japanese meditation garden was installed as a gift from Kaizuka, Japan, one of Culver City's five sister cities. The library became the Culver City Julian Dixon Library in 2001 in memory of Congressman Dixon. (Courtesy Cerra Collection.)

The railroad right-of-way along Culver Boulevard became a bike and walking path after the train tracks were no longer used. Architectural elements from the 1928 city hall were saved and many of them can be seen along the way. The path extends from Elenda Street to Sawtelle Boulevard. (Courtesy Cerra Collection.)

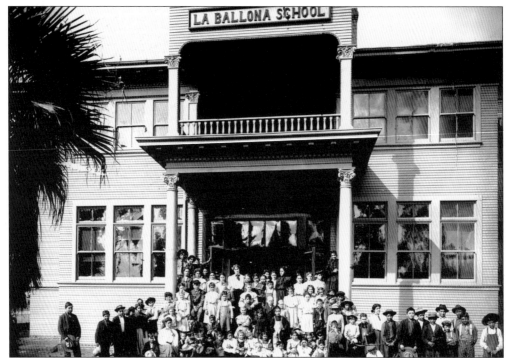

Pictured *c.* 1908, La Ballona School was the first school in the area that became Culver City. In its first year, 1865, 17 boys and 11 girls registered for the seven-month school year. Miss Craft, the first teacher, received $50 a month and room and board. The entire school budget that year was $474.50. La Ballona School became a part of the Culver City School District in the 1920s. (Courtesy Cerra Collection.)

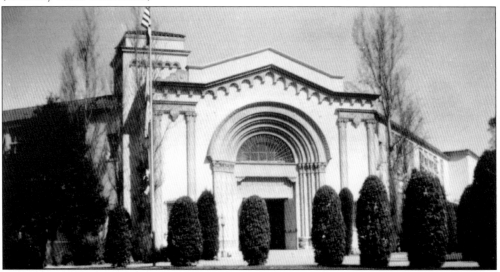

The original 1865 wood-frame school was replaced by this modern La Ballona School after the turn of the century. This photo was taken in the 1940s. The concrete structure was deemed seismically unsafe; yet when the contractor tried to demolish it, the wrecking ball had no impact and plastic explosives had to be used. The site was marked by the Culver City Historical Society as Site No. 10. (Courtesy Culver City Historical Society Collection.)

This ad gives a flavor of the local nightclubs in the 1920s. Fatty Arbuckle's Plantation Café was located across from La Ballona School at Elenda. Fatty Arbuckle, who began as a child actor, attended La Ballona as a child. Studio workers helped with the interior decoration of the nightclub. (Courtesy Cerra Collection.)

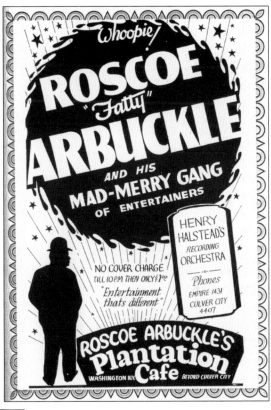

Piccadilly's Drive-In restaurant catered to the hamburger crowd when drive-ins were the rage. Located at Washington Place and Sepulveda Boulevard, it has been touted as the place "where drag racing began." Note this late 1940s menu did not offend mom, stating "Two Good Places to Eat! Here and Home." (Courtesy Machado Collection.)

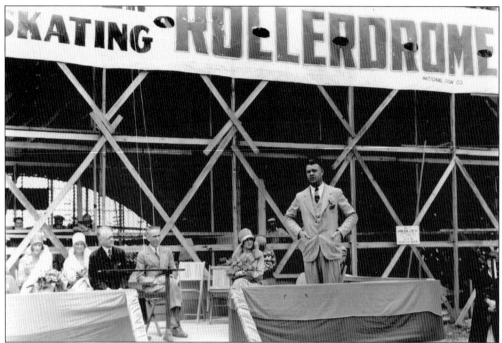

Seen here during construction, *c.* 1928, the Rollerdrome drew crowds of all ages from near and far to skate to the organist. Singles, couples, and backward skating were all great fun for date night or birthday parties. Teary eyes watched when the termite-ridden structure had to be demolished. It was replaced by Tellefson Park. (Courtesy Cerra Collection.)

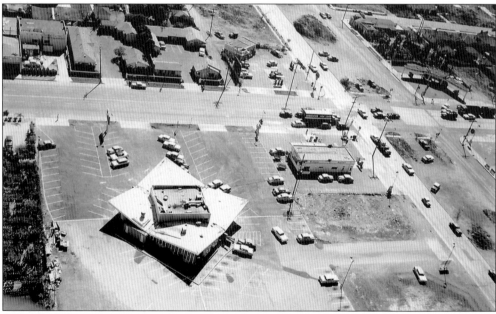

"The Clock" restaurant on Sepulveda just south of Venice Boulevard was another 20th-century teenage "hang out." This aerial photo shows that customers had the option of parking and going in to eat or having a "car hop" come to their cars to take orders and deliver them back to the car. (Courtesy Cerra Collection.)

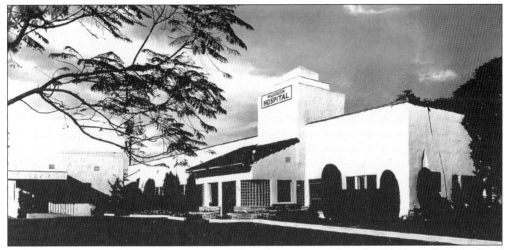

Washington Hospital, at Washington and Grandview, opened in the 1940s with 16 beds, of which 6 were used primarily for obstetrics. The hospital was founded by a mother and a daughter, both doctors. By 1999, when it closed its doors, it was a 99-bed hospital. It was redeveloped by The H.E.L.P group into a private school. (Courtesy Culver City Historical Society Collection.)

The Machado family farmed Rancho La Ballona, which extended all the way to the beach. Celery fields were plentiful. This is a reproduction of an original crate that was made for a Machado reunion. Every October the descendants of Agustín and Ygnacio Machado have a day-long family celebration. (Courtesy Machado Collection.)

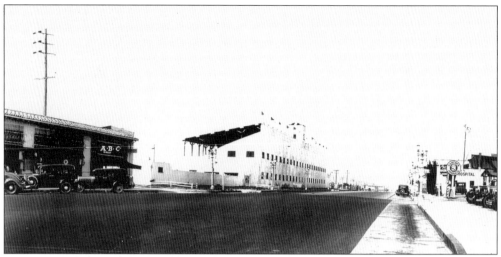

The 1924 Walnut Annexation brought the west end into Culver City, bringing the city's size to 3.2 square miles. Although some postulate that the odd-shaped addition was designed to bring in the gambling at that end, it is probably more plausible that the city wanted commercial buildings on both sides of Washington Boulevard, leading to Abbot Kinney's resort of Venice. Looking east from Lincoln Boulevard, the dog track is on the left, at the edge of the city. (Courtesy Machado Collection.)

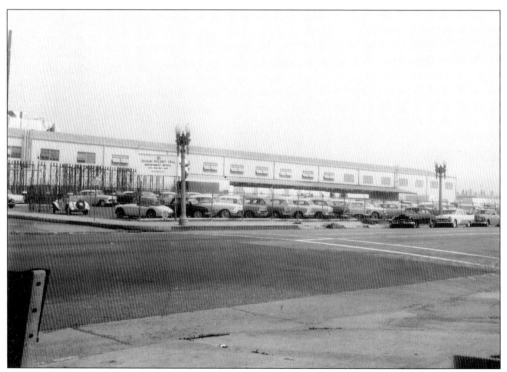

The notorious dog track at Walnut and Washington Boulevard gave way to midget auto racing and, in 1959, a Douglas Aircraft facility, pictured here. Later, it was developed into retail space. (Courtesy Culver City Historical Society Collection.)

# Five

# AND ALL AROUND
# THE TOWN

Because of the odd shape of Culver City, it is not easily divided into neighborhoods. Some annexations stand out, however. Blair Hills was part of a rugged western landscape and is almost a rural pocket of the city. Local western performers like the Pitti family had working ranches there. Will Rogers Jr.'s ranch was located just below the Pitti property. Trails were endless and cowboys were almost too numerous to count. The horses were workers. They either worked the land or, like "Warrior," became a famous performer. The area was eventually developed by Stone and Stone. The streets, like Stoneview, were named for the family. One of the Stones's grandchildren was named Blair, hence Blairstone, and of course Blair Hills.

Culver Crest was a 1950s annexation for very pragmatic reasons—they needed sewers. The primary developers were Lewis A. Crank and R.J. Blanco. The Cranks lived on top of the hill. Cranks Road was obviously named for the developer, but he also named Esterina Way for his wife, Esther. Blanco Park, next to El Rincon School, was dedicated in perpetuity for park space. Blanco Way is located in another area Blanco developed.

Fox Hills was a 1964 annexation to Culver City. Recreational use maintained it as open space in the form of 18-hole golf courses and riding stables until the 1970s. Holy Cross and Hillside Memorial Park have barely interrupted the terrain. Housing was built in the early 1970s in the form of condominiums and apartments in Fox Hills. The first major redevelopment project in Culver City, the Fox Hills Mall, was opened in the fall of 1975. Corporate Pointe served as the motivation for a group of local citizens to write a height limit initiative, which was passed in 1990. Fox Hills became a part of the Culver City Unified School District in the 1990s as well.

Walter Cameron, who made his debut in *The Great Train Robbery*, was an early western star. Cameron is pictured at left, looking east at his Ben Hur Stables on Overland and Jefferson. He supplied the chariots for the movie *Ben Hur*. This eventually became MGM's Lot No. 5 and then Raintree Plaza. (Courtesy Paul Pitti Collection.)

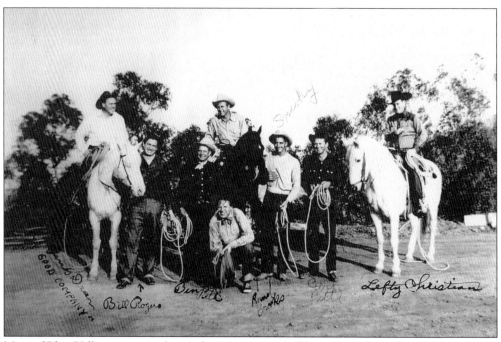

Most of Blair Hills was annexed to Culver City in 1921. These "Blair Hills Cowboys" included, third from left, resident Ben Pitti and Rand Brooks sitting on the horse next to Pitti. Stone and Stone developed this area in the 1950s. (Courtesy Paul Pitti Collection.)

Ben Pitti, a talented performer, came to California with the Al G. Barnes Circus. He held a variety of jobs, including chauffeur for Will Rogers. He is pictured with his wife, Ethel, who assisted him in his rope and knife throwing act. In 1952 Pitti, whose stage name was Bennie Pete, went on the road with Rand Brooks on his Wild West show tour. (Courtesy Paul Pitti Collection.)

Ben Pitti is pictured with Preston Foster at the Pitti Ranch in Blair Hills, *c.* 1950. The Pitti Ranch was just above the ranch of Will Rogers Jr., whom Pitti taught to ride. (Courtesy Paul Pitti Collection.)

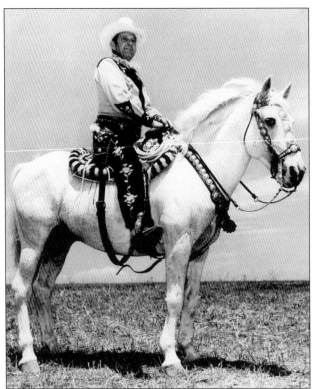

Ben Pitti poses on his horse, Warrior. In 1952, Pitti's son Paul took his daughter up to the ranch to ride. She saw the prized horse stuck in an oil sump up to his neck. They pulled him out just in time to save him. (Courtesy Paul Pitti Collection.)

The Culver Crest's landmark Youngworth mansion is a multi-level Spanish Colonial structure dating back to 1930, when avocado groves flourished below. Leo Youngworth, a Los Angeles lawyer, lost the house in 1934. Rumors of gambling and Nelson Eddy singing on the patio emerged. In 1945 Lewis Crank purchased it and developed the upper hill. Esterina Way was named for his wife, Esther, whose brother Tony Carnero owned the gambling ship *Rex* and built the Stardust Hotel in Las Vegas. The home became Marycrest Manor in 1954. (Courtesy Cerra Collection.)

Ray Blanco developed the remaining portions of Culver Crest and other portions of the city. This ad shows some of the available floor plans, with Plan K starting at $14,500. (Courtesy Culver City Historical Society Collection.)

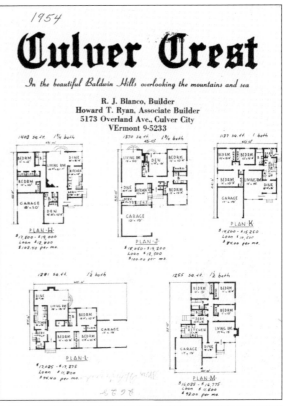

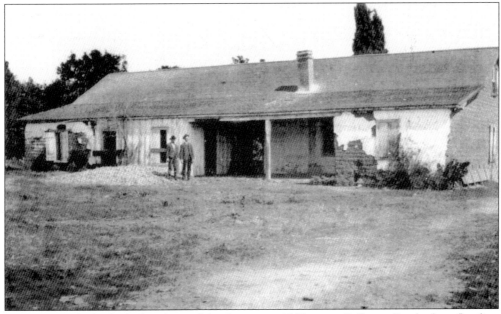

Agustín Machado built his first adobe home c. 1820 near Ballona Creek, but flooding creekwater washed it away. This is another of the Rancho La Ballona founder's homes, also an adobe. It may have been on Jefferson or Overland in what became Culver City. (Courtesy Machado Collection.)

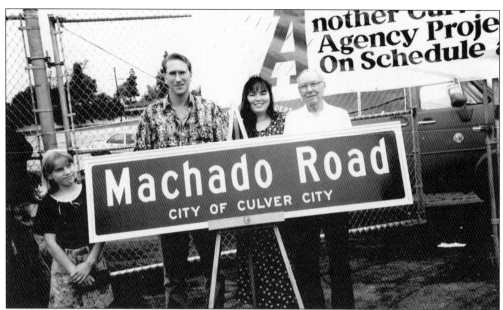

Machado Road, named for the founders of Rancho La Ballona, was dedicated in 1994. Machado relatives shown attending the ribbon cutting are, from left to right, Jasmine Machado with her parents, Michael and Angie Machado, and Machado family historian Fred Machado. The street was cut through the former drive-in property. Other new streets in that area are Agustín (for Machado), Heritage Lane (for everyone's heritage), Lantana (city flower), and Ballona. (Courtesy Culver City Historical Society Collection.)

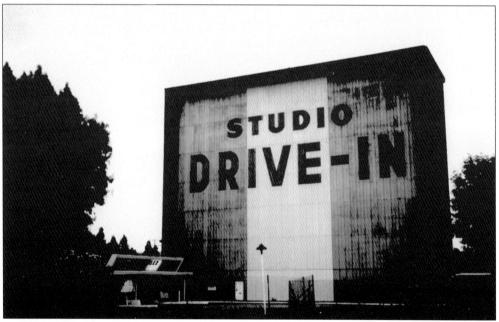

Built on Machado property in 1948, the Studio Drive-In showed its last movie in 1993. Locals have fond memories of going to the movies in the family station wagon and later as teenagers on date nights. The establishment was demolished in 1998, yielding to Heritage Park homes and a school. (Courtesy Cerra Collection.)

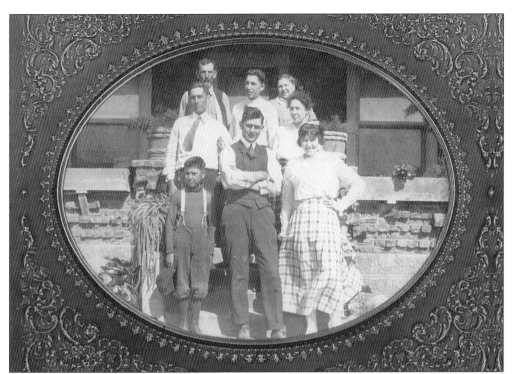

The Lugo Ranch was the last working ranch in Culver City. A gift of family land to Agustín Machado's grandson Mercurial Lugo, it was located at Cota Street and Jefferson Boulevard. Lugo was the *zanjero* (water overseer) in the area as well. Shown here are Mercurial and Rita Reyes Lugo with some of the family *c.* 1930. Vicenta Lugo, one of the eight children, sold the property to R.J. Blanco in the 1950s for a shopping center. (Courtesy Cerra Collection.)

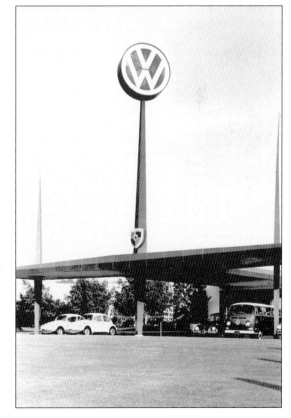

In the 1960s, as Overland turned into Playa Street, there was a very modern building that housed the headquarters of VW Pacific. Although the building no longer exists, photos record the work of noted architect Paul Williams. Williams also designed the Al Jolson Memorial in Culver City, the "theme" building at nearby Los Angeles International Airport, as well as a variety of grand homes, banks, and offices. (Courtesy Cerra Collection.)

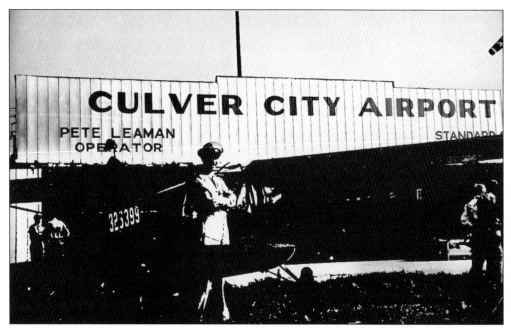

This is a 1940s photo of the Culver City Airport, originally called the Baker Airport in the 1920s when it was owned by Baker and Blair. It was located at Mesmer and Jefferson, extending to what is now Sepulveda Boulevard. Flying lessons at that time cost about $8 each. (Courtesy Petrelli Collection.)

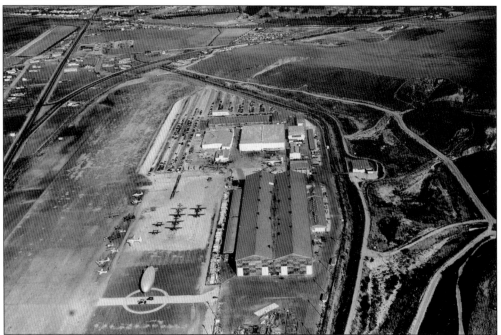

This aerial shows the Culver City Airport in 1946 and the nearby Hughes Aircraft plant and its runway. Hughes built his Spruce Goose in one of the hangars. Although just west of Culver City, Hughes, one of the major employers of the area, had a Culver City mailing address. (Courtesy Petrelli Collection.)

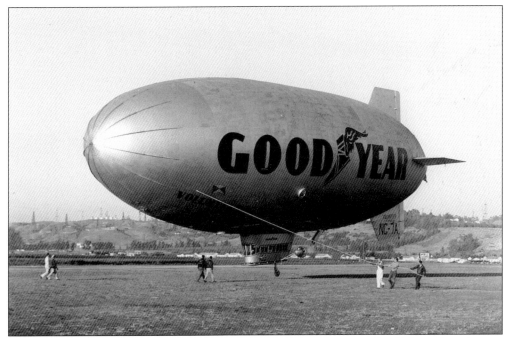

The Goodyear blimp, a welcome sight to locals, touches down at the Culver City Airport in 1947. Baldwin Hills, dotted with oil wells, are in the background. (Courtesy Petrelli Collection.)

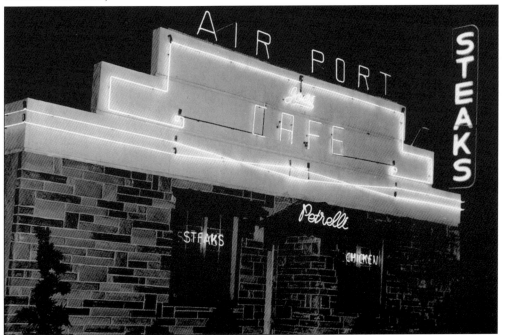

Joe Petrelli's Airport Café as it appeared in 1931 at the Culver City Airport. According to George Petrelli, his uncle Joe simply "slid" the old building across the street. Petrelli, a master butcher, was widely known for his steaks. Joe Petrelli died in 1958, but the Petrelli tradition continues at Geo. Petrelli's. (Courtesy Petrelli Collection.)

George Petrelli still cuts the meat for his steak house just like "Uncle Joe" Petrelli taught him. George came from Italy in 1956 to work for his uncle in the meat department. The new Petrelli's restaurant was part of the redevelopment of that area. (Courtesy Petrelli Collection.)

The "Westernaires" enjoyed riding and singing. Paul Pitti, front, is seen playing the guitar and singing with his brother, stunt man Carl Pitti, and Carl's wife, Mickey. The Pitti family is a longtime Culver City family. This photo was taken at Sunset Stables in Fox Hills c. 1946. (Courtesy Paul Pitti Collection.)

A 1964 annexation to Culver City, Fox Hills, once known for its golf courses, cemeteries, and stables, is pictured in the top third of this 1970s aerial shot. The San Diego Freeway crosses the bottom of the picture. The mall opened in 1975 as the first major redevelopment project. (Courtesy Cerra Collection.)

The Fox Hills Golf Club, a.k.a Fox Hills Country Club, ran tournaments regularly. Studio employees June Caldwell, second from left, and Jean Kleopfer, right, take a break with other MGM studio workers at the studio tournament c. 1943. At the 6th Annual Culver City Open, the Chamber of Commerce advertised their 1951 event as "The Biggest Little Tournament on the Pacific Coast." (Courtesy Barker Collection.)

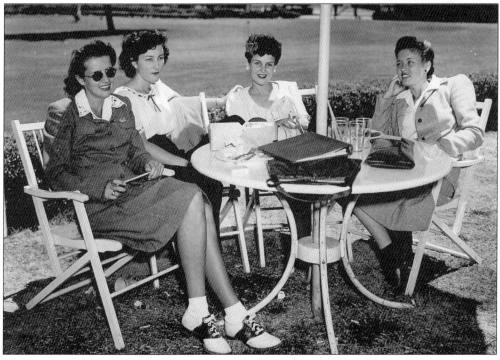

Hillside Memorial Park had its beginning in 1941 as B'nai B'rith Memorial Park when Fox Hills was in county territory. The name changed in 1950, and Fox Hills was annexed to Culver City in 1964. The Al Jolson Memorial, designed by famous architect Paul Williams, rises above a 120-foot waterfall at the resting place of the famous star. (Courtesy Hillside Memorial Park Collection.)

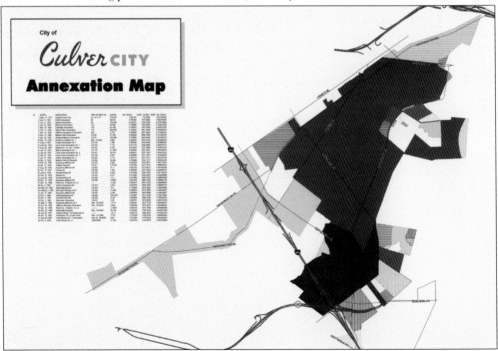

Through 42 annexations, Culver City has grown from 1.2 square miles to just under 5 square miles. These little additions explain the irregular boundaries of the city. (Courtesy City of Culver City.)

# Six

# PEOPLE, PARKS, AND COMMUNITY CELEBRATIONS

People make a community. Over time, Culver City people established organizations, events, and celebrations to suit them, and they have changed over time. Tom Sawyer Days was replaced by Fiesta La Ballona Days, a celebration of the local heritage. It was a summer week packed with activities for everyone.

Park space has been a priority from the beginning of Culver City history. Harry Culver's first park is not officially within the city boundaries but is an indicator of recreation as a priority. The first park in Culver City was actually Victory Park, later renamed for medical missionary Dr. Paul Carlson. Park space continued to grow from there, often named for people who were important to the community.

Blanco Park was dedicated in the name of developer R.J. Blanco and became a good example of the joint use agreement between the city and unified school district. It is used by El Rincon School during the day but reverts to public park space after school. Coombs Park reflects the importance of the Coombs family, who continue the tradition of community involvement. McManus Park became Syd Kronenthal Park to honor the longtime head of the city's recreation department, while the Rollerdrome site became Tellefson Park, a bicentennial tribute to Michael Tellefson. Bill Botts Field, named for a councilman, is a part of the largest park, Culver City Park. It offers park space at the bottom of the hill, fields for baseball and soccer above, with other opportunities like a walking track, skateboard park, and upcoming dog park. Veterans Memorial Park commemorates those who served our country.

Culver City is truly an oasis within the urban metropolis. It stands alone, with its own parks, fire and police services, and schools. Local officials are accessible, and the city follows a tradition of recognizing those who contribute.

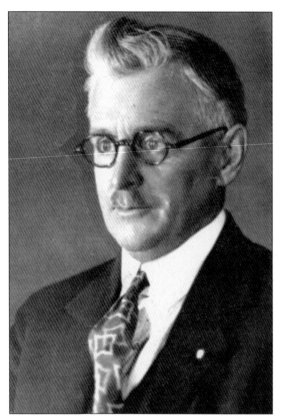

Councilman Dan Coombs is pictured in 1928. A Culver City park and a street carry the family name. Coombs, a local contractor, built throughout Culver City. His contract for building Fatty Arbuckle's Plantation Café nightclub required completion in a month, a condition which he met. (Courtesy Coombs Collection.)

Culver City VIPs were on their way to greet a visiting Charles Lindbergh when this photo was taken. Police Chief William Coombs, brother of Councilmember Dan Coombs, drove the city officials and press. *Culver City Star* reporter Harold Jones, who donated this photo, is on the far right. (Courtesy Culver City Historical Society Collection.)

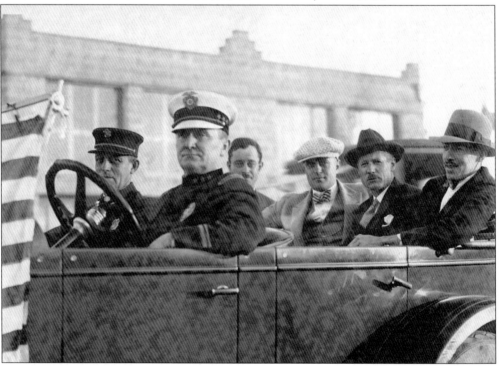

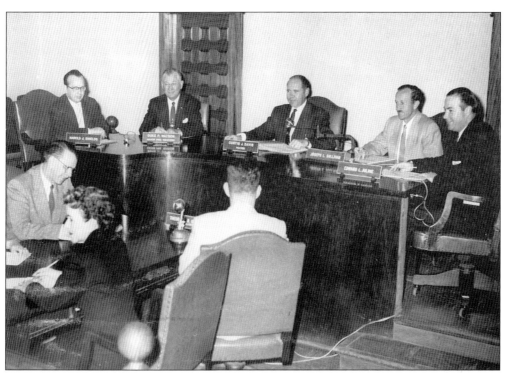

The 1928 city hall was built with council chambers to accommodate regular meetings like this one in the mid-1950s. From left to right on the platform are Councilmembers Harold Shields and Duke Watson, Mayor Curtis Davis, and Councilmembers Dr. Joseph Sullivan and Ed Juline. Culver City Council members are elected at large and receive an honorarium for their "after work" commitment. (Courtesy Culver City Historical Society Collection.)

Mary Lou Richardson served as mayor from 1958 to 1959. Richardson was the first woman elected to the Culver City Council. Following her, Jozelle Smith became the first second-generation councilmember (her father, Joe Lawless, also served), and Sandra Levin and Carol Gross followed them. Women were elected to other duties, such as Katherine Megary, an early city clerk who also received an extra $25 a month for acting as janitor. (Courtesy Culver City Historical Society Collection.)

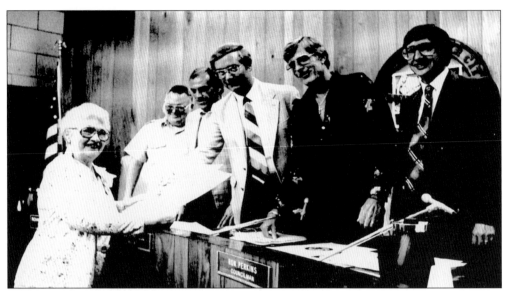

Teacher Gladys Chandler moved to Culver City in the 1920s, where she became a principal and active community member. Council members recognizing her efforts are, from left to right, Richard Alexander, Richard Brundo, Paul Netzel, Ron Perkins, and Paul Jacobs. Chandler was married to city employee "Wink" Chandler, and her sister, also very respected, was Kathryn Bernard. (Courtesy Culver City Historical Society Collection.)

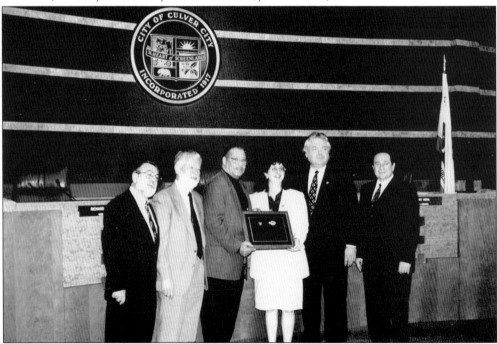

The Honorable Julian Dixon served as Culver City's congressional representative for the last 22 years of his life. He was always an advocate for Culver City and a conduit for needed funds. He is shown here in the council chambers in the late 1990s at center with, from left to right, Council members David Hauptman, Albert Vera, Sandra Levin, Richard Marcus, and Ed Wolkowitz. (Courtesy Cerra Collection.)

Police Chief Ted Cooke was the longest serving chief in the state when he retired in 2003. He is pictured enjoying a conversation with Los Angeles County Supervisor Kenneth Hahn. A park in nearby Baldwin Hills is named in honor of Hahn. Yvonne Brathwaite Burke continued the 2nd District's support of Culver City. (Courtesy Culver City Historical Society.)

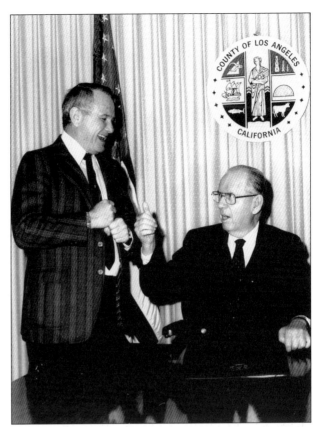

After Kaizuka, Japan's gift of a meditation garden for the front of the Culver City Library, the Sister City Committee wanted to reciprocate. A delegation from Culver City is shown in front of a sculpture, "Man, Woman and Child," by artist Natalie Krol, that was commissioned by Culver City for the people of Kaizuka. The visitation in 1977 is just one of many ongoing exchanges. (Courtesy Freiden Collection.)

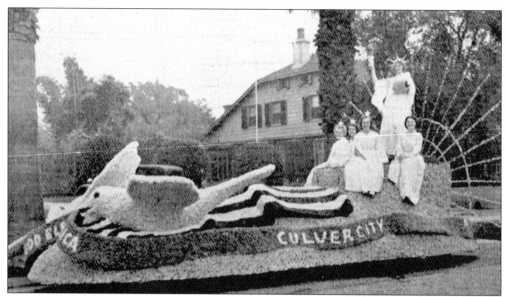

Pasadena's New Year's Rose Parade is a festive tradition in which even small cities like Culver City can enter floats. This 1940 Culver City float reads "God Bless America" on the front. It was pictured on a folding postcard with other participants that year. (Courtesy Cerra Collection.)

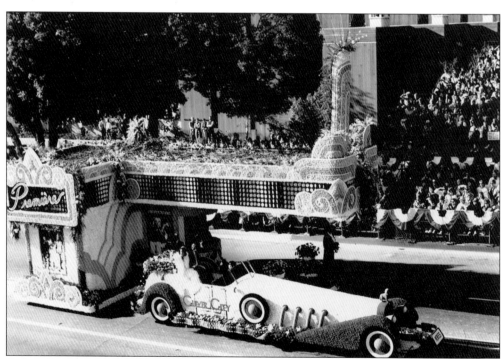

Culver City's Convention and Visitors Bureau spearheaded four floats in the 1980s, all geared toward the movies. This 1985 entry was the first of four that decade and was appropriately named "Premiere." (Courtesy Culver City Historical Society Collection.)

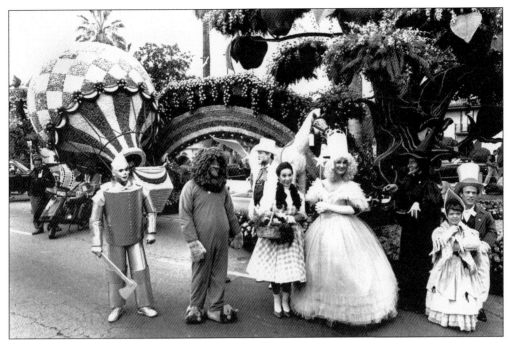

In 1986 Culver City won the Theme Trophy for "Kings of Comedy," entered "Movie Magic" in 1987, and received the Director's Trophy for this 1988 "Fantasy on Film." Local resident Carol Matlow won the distinction of playing Dorothy in the fundraiser auction. (Courtesy Culver City Historical Society Collection.)

This is not exactly a fearsome foursome breaking ground for Culver's new track—assemblymember Herb Wesson (on tractor), Rosie Greer, former mayor Mike Balkman, and Mrs. Balkman. Wesson and his wife raised their sons in Culver City as active community members. Wesson, Culver City's first resident to become the speaker of the California State Assembly, has been a conduit for funds for local projects. The track was later named in memory of Balkman. (Photo by Christina V. Davis for the Wesson Collection.)

Culver City students attended Venice or Hamilton High until the people voted for a Unified School District in 1949. Youngster Marilyn Freiden holds her handmade sign asking "Please give us our high school," c. 1950. Her mother, Bessie Freiden, was a force in lighting Helms Field after the school was built. (Courtesy Freiden Collection.)

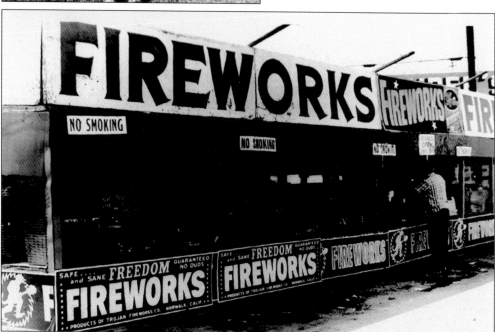

The 4th of July meant potlucks and fireworks after dark in early times. M.V. Bell, mother of a local doctor, headed the Culver City Fireworks Company. Stands were located throughout the city for firework sales. Although the City Council voted out neighborhood displays in the late 1980s, the Exchange Club sponsors a public display at the high school every year. (Courtesy Culver City Historical Society Collection.)

116

The Culver City Speedway, a board racing track, replaced a short-lived horse racing track in the early 1920s. In 1928 it became Victory Park, which was located in the center of streets that circled it. (Courtesy Culver City Historical Society Collection.)

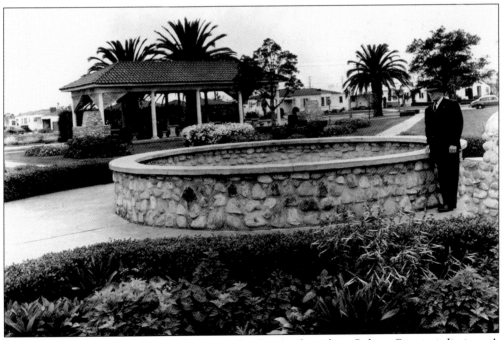

Built on the speedway, Victory Park was the first park within Culver City jurisdiction. A pavilion was built with tables beneath and a barbecue nearby. Other amenities included this circle, which some residents used to teach their children to rollerskate, while others trained their dogs. (Courtesy Cerra Collection.)

Victory Park was a popular place for family picnics and children's birthday parties, like the one shown here c. 1949. Mayor Reve Houck asked for names for this first park to no avail. Legend has it that Mrs. Houck suggested Victory Park because it was "a victory to finally have a park!" (Courtesy Cerra Collection.)

The historical division of the Culver City Chamber of Commerce unveiled a marker in Victory Park in 1963 honoring seven early settler families (Machado, Talamantes, Higuera, Lugo, Ybarra, Saenz, and Rocha). Shown, from left to right, are Mayor Dan Patacchia, Amada Szanthoffer, Vicenta Lugo, Senaida Lopez, Jerry Talamantes, Carlo Machado, Ella Cheuvront, Senaida Sullivan, Clarita Young, Charles Lugo, and Carryl Wild from the chamber, as well as John Boyd, former chamber president. (Courtesy Culver City Historical Society Collection.)

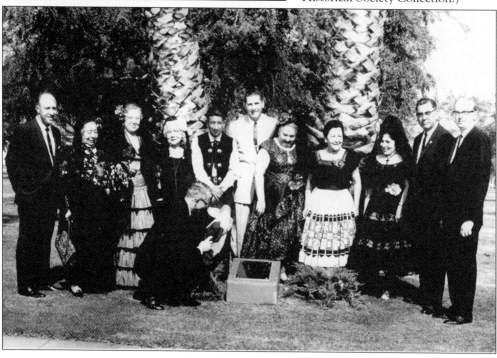

In the 1960s Victory Park was renamed Dr. Paul Carlson Park for a medical missionary who lost his life in the Belgian Congo. In 1993 President Clinton talked about health care in the same park. Props were supplied by Sony Pictures. (Courtesy Cerra Collection.)

Culver City's Veterans Memorial Auditorium was renovated in 1980. The following year, a stainless steel sculpture, "Filmstrip, U.S.A." by Natalie Krol, was completed. Financed primarily through donations, tiles around the fountain display the names of those who contributed. The always supportive Patricia Culver Battle, daughter of Harry Culver, is pictured in front of the sculpture in 1985. (Courtesy Freiden Collection.)

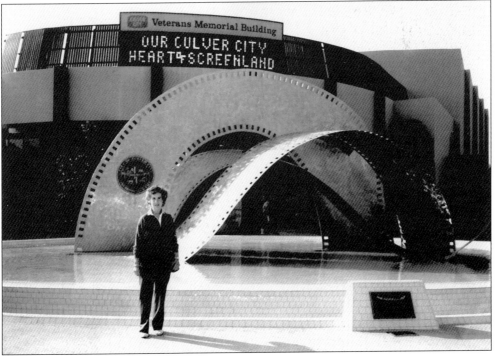

The initial acquisition of land for Veterans Memorial Park (first called Exposition Park) was in 1938. The 10.95-acre parcel, exclusive of the library building, became Veterans Park in 1949. In 1950 the bond-funded Veterans Memorial Building (shown here c. 1956) became a reality, with a tall "tourist tower" that promised a view into movie back lots. The tower chimes were a later gift from the Rotary Club. (Courtesy Cerra Collection.)

"The Plunge" at the south side of Veterans Memorial Park was completed just prior to the dedication of the Veterans Memorial Building. From the 1950s, local children learned to swim and played together in the pool, and many came back for jobs as summer lifeguards. This was the location of many aquacades, especially during the fiestas. (Courtesy Cerra Collection.)

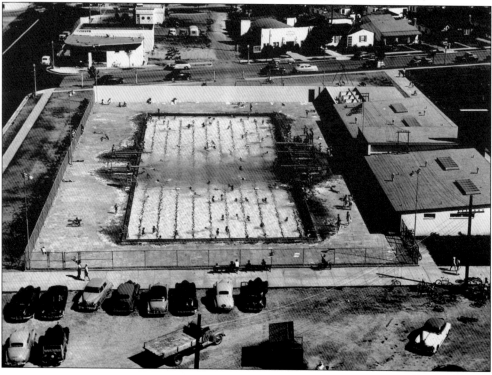

The Culver City Historical Society preserves the history of the local area. Founding members Jimmy and Bessie Freiden are pictured doing a "rubbing" of a plaque at a society activity in Veterans Memorial Park. Jimmy Freiden was usually on the other side of the camera. (Courtesy Culver City Historical Society Collection.)

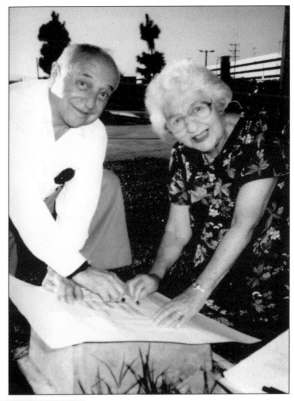

Everyone enjoys activities in the park. At the same event, young "historians in training," Michele Cerra and Susan Diviak, try their hand in preserving history. Bronze markers throughout the city offer endless opportunities to learn and to make rubbings as a record of what is already acknowledged. (Courtesy Culver City Historical Society Collection.)

Michael Tellefson served the city for over 30 years in a variety of capacities, from city attorney to chief administrative officer to mayor. His service was recognized by the naming of a street and a park in his honor. (Courtesy Culver City Historical Society Collection.)

Syd Kronenthal was honored before he retired with the 1992 renaming of McManus Park in his honor. Council members shown positioned behind Syd, who is at the microphone, are, from left to right, Paul Jacobs, Steven Gourley, Mike Balkman, and Jozelle Smith. (Courtesy Cerra Collection.)

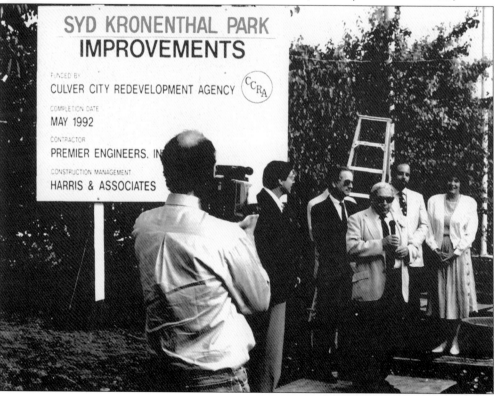

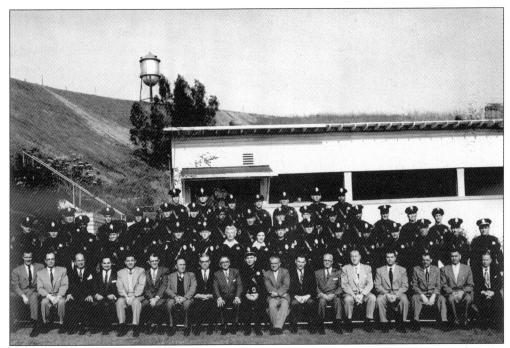

This photo pre-dated Culver City Park. It is the police range, which was located in the Baldwin Hills. At one time there was a range at Lindberg Park. The qualifying range is now located inside the police station. (Courtesy Cerra Collection.)

Honorary chair of Culver City's 75th Anniversary Committee, filmmaker Hal Roach is pictured arriving at Columbia (now Sony) Pictures at the January 1992 kickoff celebration. Roach, who brought his studios to Culver City in 1919, turned 100 years old that week. (Courtesy Cerra Collection.)

Tom Sawyer Days was an early celebration of community spirit. Employees of the Bank of America on Main Street are shown dressed up to enjoy the festivities. The Culver Hotel can be seen across the street out of this second-floor window. (Courtesy Freeman Collection.)

Elected Culver City officials are shown on their float for a community parade. (Courtesy Culver City Historical Society Collection.)

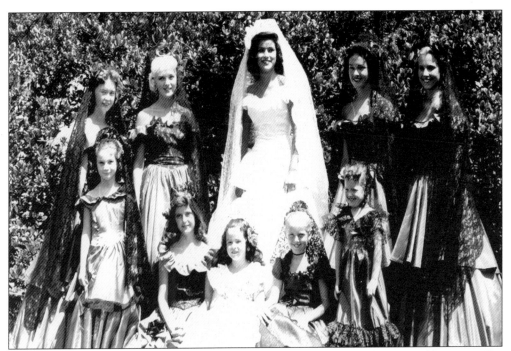

The Fiesta La Ballona began in 1951 as a weeklong celebration of pride in local heritage. The Fiesta Queen and her court are shown with the Little Fiesta Queen and her court. Both rode on a float during the Fiesta Parade. (Courtesy Culver City Historical Society Collection.)

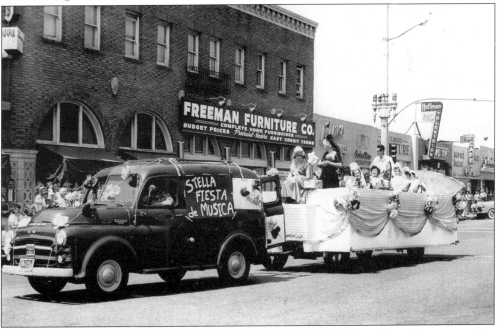

Floats for the Fiesta parades in the 1950s were "homemade" and creative. Local businesses, like Stella Music, celebrated along with the descendants of the early settlers, the scouts and performers. There was also a kiddie parade with floats made by the parents for their children to pull. (Courtesy Culver City Historical Society.)

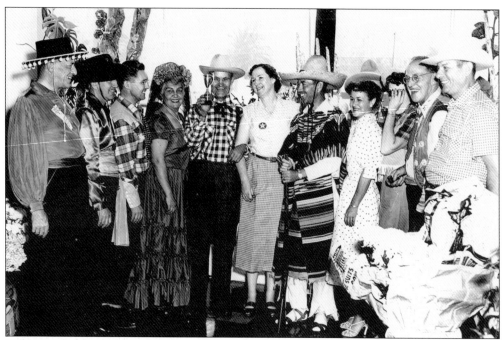

The Tingers, owners of Culver City Flowers, celebrate their trophy for window or float entry, surrounded by Fiesta participants. Local businesspeople dressed for the occasion, especially on Friday. (Courtesy Culver City Historical Society Collection.)

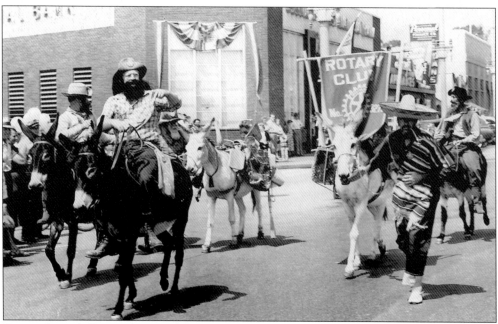

During the early Fiestas, service clubs, scouts, and bands joined the parades. The Rotary Club is having fun, dressed to impress! (Courtesy Culver City Historical Society Collection.)

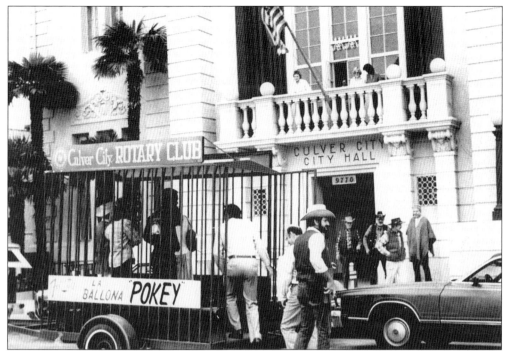

By the 1970s, the Fiesta transitioned into a "Festival of the People" led by local sign maker and chamber president Gus Prado. Prado is shown in front of city hall rounding up everyone who was not dressed up for the day. The "pokey" was manned by the service clubs. (Courtesy Culver City Historical Society Collection.)

In simpler days, graduations were big milestones. In Farragut Elementary's Class of 1957, one of the boys became a school board member and another has since retired from the city—and still has the same haircut! (Courtesy Newton Collection.)

The sides of Ballona Creek were reinforced in 1935 by the Army Corps of Engineers because of flooding. Here, the normally placid creek is seen after a rain in 1958. The motivation for the footbridge was the safety of Farragut Elementary students. An assessment district financed the first footbridge over Ballona Creek and a new one was built in 2004. (Courtesy Security Pacific Collection/Los Angeles Public Library.)

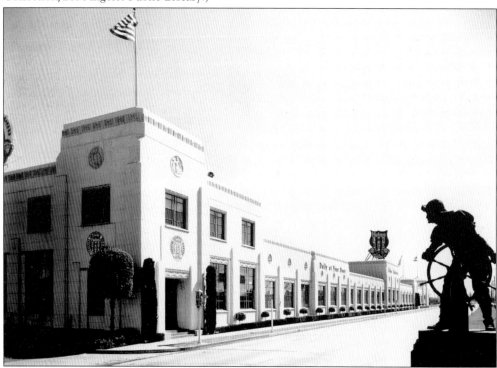

The Helmsman sculpture indicated the presence of Helms Bakeries at one time. Although it was actually on Venice Boulevard in Los Angeles, the statue was a welcoming sight to Culver City residents. The bakery closed in 1969, but if you want to see the Helmsman today, just drive past the west end of Culver City to Chace Park at Marina del Rey. (Courtesy Cerra Collection.)